Lettering
TO THE MAX

Text and graphics
Ivan Castro

Translation
Steven Scicluna

Photography: **Ivan Castro**, except: **Oriol Miró**, p.12; **Nick Benson**, **Alex Trochut**, **Jon Nordstrøm** and **Antonio Jorge de Oliveira Junior**, p.13; **Miguel Márquez**, sleeve and p.14; **British Library**, p.26; **Lino Rodríguez Outeiral**, p.109; **Fabrikat, Zurich**, p.120.

Design of inner pages, cover and pre-printing
Ivan Castro

Designed in Adobe® InDesign CS6, and typeset in Schotis, by **Juanjo López**, and Nomada, by **Jordi Embodas**

Originally published in Spanish as *Lettering A Tope* © 2018 LAROUSSE EDITORIAL, S. L.

First Published in English in 2020 © Korero Press
ISBN-13: 9781912740079

www.koreropress.com

All rights reserved. With the exception of quoting brief passages for the purposes of review, no part of this publication may be reproduced, stored in a retrieval system, or transmitted in any way or by any means, electronic, mechanical, photocopying, recording or otherwise without the prior written permission of the publisher. The information in this book is true and complete to the best of our knowledge. Every effort has been made to ensure that credits accurately comply with information supplied.

A CIP catalogue record for this book is available from the British Library.
Printed and bound in China.

Lettering
TO THE MAX

Master the fundamentals of drawing letters with style

Ivan Castro
Preface by Alex Trochut

KORERO
PRESS

For Eva and Aurora, the women of my life.

CONTENTS

Foreword — **6**

SO, WHAT IS LETTERING? — 8
Calligraphy, lettering and typography — **11**
My life as a letterist — **14**
Tools and materials — **19**

BASIC PRINCIPLES — 22
A history of calligraphy for dummies — **24**
The importance of structure — **28**
The anatomy of a letter — **33**
Variable factors — **34**
Bold, thin, axes and contrast — **36**
Drawing techniques — **40**
Rhythm, spacing and form — **44**
Optical adjustments — **48**
Different approaches — **53**
Composition — **61**

DIFFERENT STYLES — 70
Sans-serif — **72**
Serifs — **76**
Brush calligraphy — **80**

LET'S GET TO WORK! — 88
Project phases — **90**
A matter of style — **93**
Project: Logotype for a band — **94**
Working digitally — **97**
Project: Travel album — **100**
Project: Painting a denim jacket — **104**
Project: Decorative sign — **110**
Project: Painting a shop window — **116**
Traditional sign painting — **120**

Conclusion — **124**
Bibliography — **125**
Acknowledgements — **127**

FOREWORD

How and where to start? Talking about the art of drawing letters is talking about one of the essential aspects of being human – without letters, we would probably still be foraging for bananas in the forest. It is a very big topic, if you know what I mean. Somehow, Ivan Castro thought I was a good fit to write the Foreword to his book, and so here we are... In order to do this, please bear with me while I go slightly off-topic to illustrate a point.

Do you remember the song "Every Breath You Take" by The Police? Such an immensely popular song – it has been on the radio and in our heads since 1983, and when you hear that guitar arpeggio, you can't help but sing along. A total classic, very sticky, an absolute timeless hit, and a perfect karaoke choice (maybe not).

Well now, I'm not sure whether you have paid close attention to the lyrics that Sting wrote. If you have, you might have noticed the notorious disparity between the sweet and tender melody of this pop ballad and its lyrics, which depict the surveillance activities of a creepy stalker towards his ex. Can you hear the lyrics in your mind, without the music? Ok, that's a pretty unhealthy love song, right? But still, some people have used it as the "first dance" song at their wedding.

See, *that* is how influential the delivery of a message can be, and how it can totally change, alter or erase its content. And in many ways, that Police song is a perfect case study for me to explain what we lettering artists do. Don't get me wrong: most lettering artists never get to write the lyrics of a super-hit, and as far as I know, they are not stalkers, either. But my point is that lettering artists are the ones responsible for creating the music.

Yes, The Music. The Music of the song that we hear in our heads, every time we look at carefully designed lettering instead of just plain text. We don't get to write the text, or even to choose it, but we are, nonetheless, the music makers (and we are the dreamers of the dreams).

Well, my friend, you are holding in your hands the key to those mind control skills. Let Ivan Castro turn over to you the millenary knowledge he has been collecting throughout his long career as a lettering master and entrust you with the abilities that can change people's minds. I wish you the best in this journey – may its teachings take your hand and soul to a higher place.

Alex Trochut
Brooklyn, New York, USA, 2020

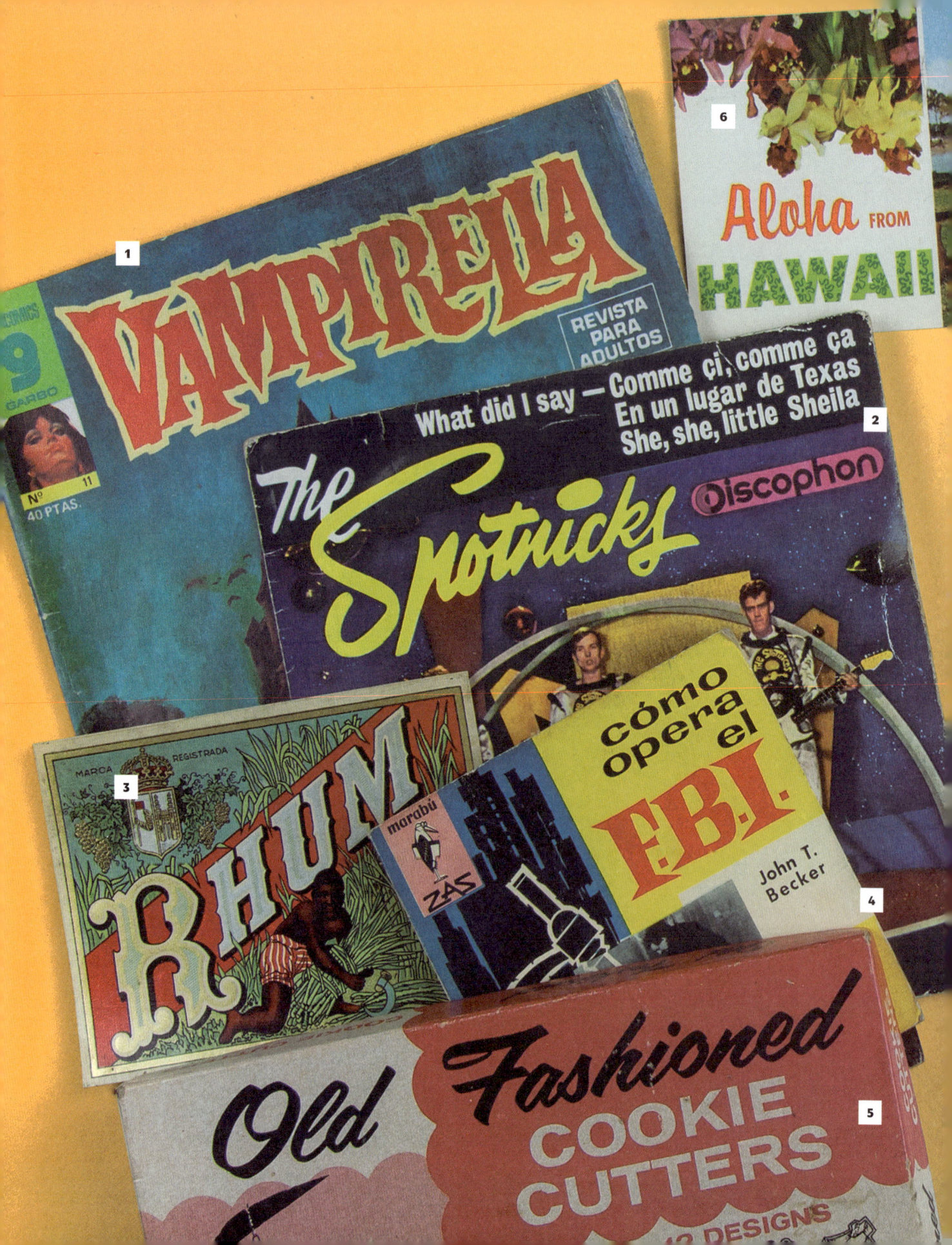

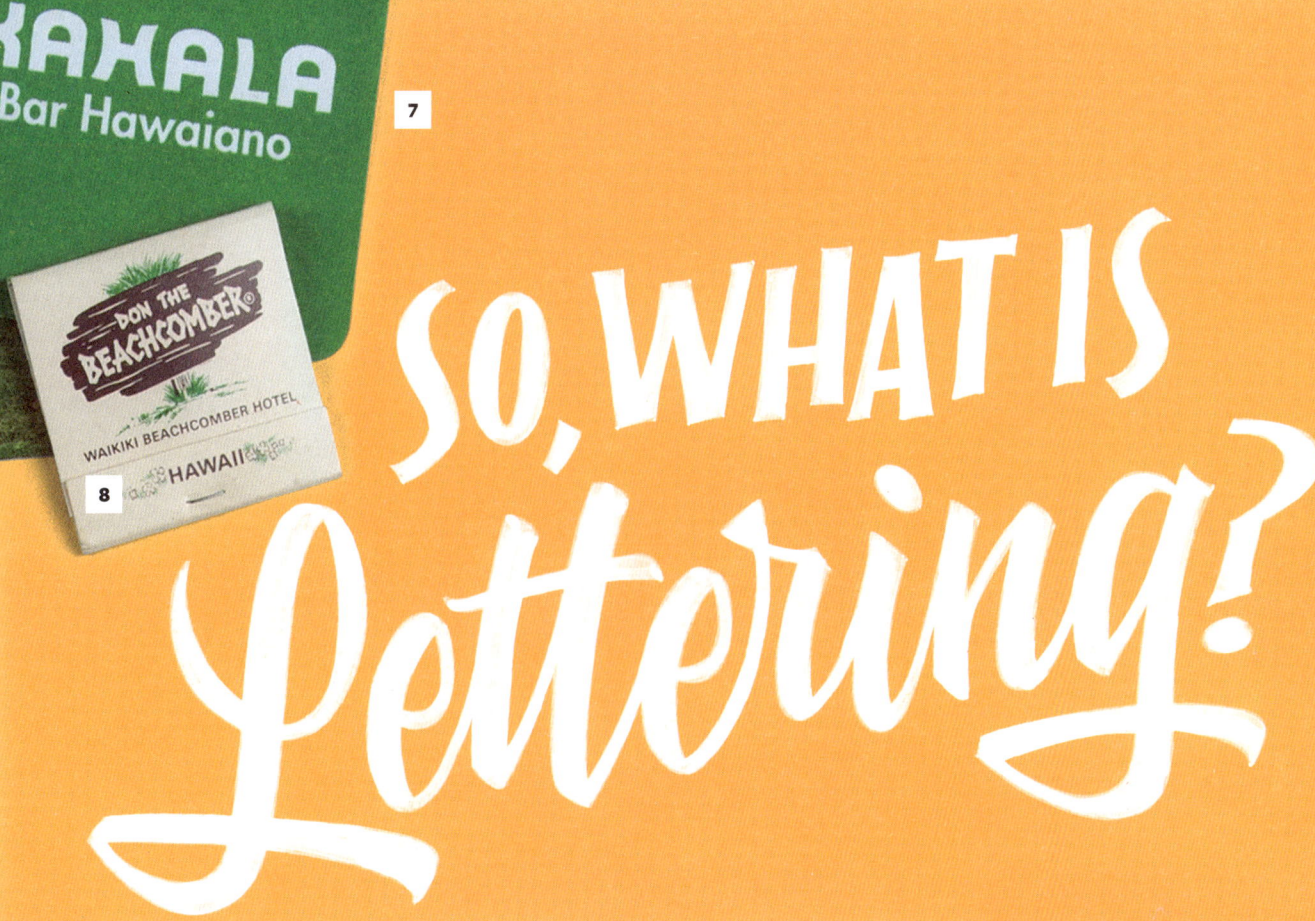

So, what is Lettering?

Typography is a language that has always surrounded us. From the numbers on the alarm clock that goes off every morning to the logotype on the toothpaste tube we use every night before we go to bed, most of our days are spent receiving and processing hundreds of typographical messages.

Apart from the inherent textual information that such typographical elements transmit to us, they communicate information that works on other levels too. Let us take a simple comparison. When we speak, we use a particular tone of voice, and we also apply certain stresses on the words we pronounce to give them the characteristics we want them to have. For example, the tone we use when speaking to a loved one is probably not the same as the one we use when sending another person packing. In each case we use a different inflection, volume and velocity to convey the intention of the message we are communicating. The same thing goes on when it comes to composing a message using typography: I am sure it is not too hard to imagine the delicate lettering we would use when writing down a loving poem, or the fat, heavy typography reserved for the most offensive of insults.

◄ A few samples from my vintage print collection, which contains some excellent lettering examples.

1 *Vampirella* n. 11 comic magazine.

2 EP by The Spotnicks, an instrumental rock band.

3 A rum bottle label.

4 A paperback book cover.

5 Packaging for a set of cookie cutters.

6 A postcard from Hawaii.

7 Coasters from Kahala cocktail bar.

8 A book of matches from Don the Beachcomber, a Hawaiian restaurant.

Amor Mio

BASTARDO

▲ Two examples of lettering that visually reflect the intended message. In the first example, the typeface Snell Roundhand suits the romantic tone perfectly. In the second example, the typeface Voodoo House reinforces the violent tone of the message.

Therefore, the idea of choosing an appropriate style of letter that amplifies the message as much as possible has clear benefits. In visual communication (graphic design and advertising, mostly) typographic language is typically used rhetorically, even poetically in some cases. Someone who works in design professionally would have to know the medium well and possess a wide knowledge of different typefaces to be able to deliver words with a specific message to viewers. New typefaces are published daily by type foundries, and these are then added to an already extensive type catalogue.

Still, there might be cases that, due to the technical limitations of digital typefaces (we will speak more about this soon), leave us unable to find a font family which caters to our specific needs. Maybe we have a particular typeface in mind that we cannot locate, or perhaps we are looking for one which is more dynamic or needs to be warmer than the digital versions on offer. Just as we head off to the tailor for bespoke clothing whenever we cannot find any off-the-shelf garments suited to our purpose, so we may have to commission a lettering specialist to create a custom logo, text or title.

Lettering, calligraphy, sign painting, hand-drawn type, hand lettering, signwriting, fonts, script typography, brush lettering... in recent years we have seen a lot of terms — some of them strictly 2.0 – like these being used indiscriminately to speak about a discipline which, ultimately, boils down to drawing (or writing) letters. I believe that to start speaking about the subject, we need to more or less clarify what each of these terms mean.

CALLIGRAPHY, LETTERING AND TYPOGRAPHY

Letterforms can be addressed from various points of view, depending on the technique and process that we apply and the intention that we have. Even though, as we will see later, this subject can be categorized and subdivided in any way we like, broadly speaking we can identify three disciplines: calligraphy, lettering and typography.

Calligraphy consists of constructing alphabetical signs using writing tools, and drawing each part of a letter in one single stroke. Generally, calligraphers start by copying established letterforms, and these will eventually be adapted and remoulded until they come to form part of that calligrapher's personal style. The relationship between the brain, the hand, the writing tool and the paper is very direct, and as a result it produces calligraphic marks that are unique and spontaneous. In short, calligraphy is mostly associated with the act of writing.

As with calligraphy, lettering is for the most part created manually, but the approach is totally different. In this case we create letters based on their outline or form. Using a drawing tool such as a pencil or a computer, we are at liberty to draw as many outlines or strokes as are needed to give shape to the forms we have in mind. The focus here is different: if calligraphy is based on manual skill, we can say that lettering is more of a mental process. It consists of taking decisions and applying them to *letterforms* over which we have total control – from their shape to their finish. Let's say that in the case of lettering, we should think of letters as being *drawn* rather than *written*.

Despite their differences, calligraphy and lettering share various common factors; both are used to create a specific result which is often inseparable from its accompanying content. For example, if I write a phrase for an advertising campaign using calligraphy, it will be almost impossible for anyone else to use those specific words or letters separately in any other context.

Conversely, typefaces facilitate reproduction. A typeface is a system of alphabetical symbols created by a type designer which another person may use for a graphic project that is governed by their own standards. Digital fonts are currently the standard in typography, but historically there were other formats, such as wood and lead type (which are currently undergoing something of a revival), or more obscure systems such as phototypesetting, monotype or the simply fantastic linotype. All of the formats have one thing in common – the typeface is delivered readily designed to the end-user.

1 In the sequence below, calligrapher Oriol Miró uses a fountain pen to develop a logotype for a wine label in the Copperplate style.

2 The finished logotype, *La Pell*, vectorised by Joan Carles Casasín and Oriol Miró, is shown on the right.

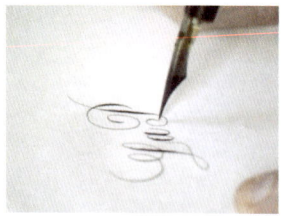

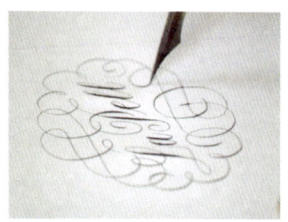

On the other hand, within these broad categories, one finds many more subcategories specific to the technique and the objective of the project at hand, including ones which are a combination of various techniques. For example, we can design a logo starting with a calligraphic technique, trace it digitally and edit its outline using a digital vector program. Should we call this calligraphy or lettering? And what about a typeface that imitates manual handwriting? It is easy to get lost in such arguments, but to be honest it is really not that important.

We also find different applications for hand-drawn letters that are classifiable as lettering, according to the definition presented on the previous page, but which in reality are at times a different discipline altogether. In this case, the technique used goes on to partly (or fully) condition the final look of the letters. From classic applications such as stone engraving or traditional signwriting, to contemporary ones such as 3D design and tattoos, lettering is a wide-ranging discipline that accommodates all kinds of solutions.

Of course, let's not forget that in the end we are merely talking about various ways of approaching the same thing: letterforms. Despite there being differences in techniques and ways of approaching a project, the logic behind creating letters is essentially always the same. Having a good understanding of the rules that govern the alphabet is crucial if we are to create letters successfully, and this is what this book is all about: rhythm, spacing, proportion, thickness, and other terms with which you will become familiar as we go along.

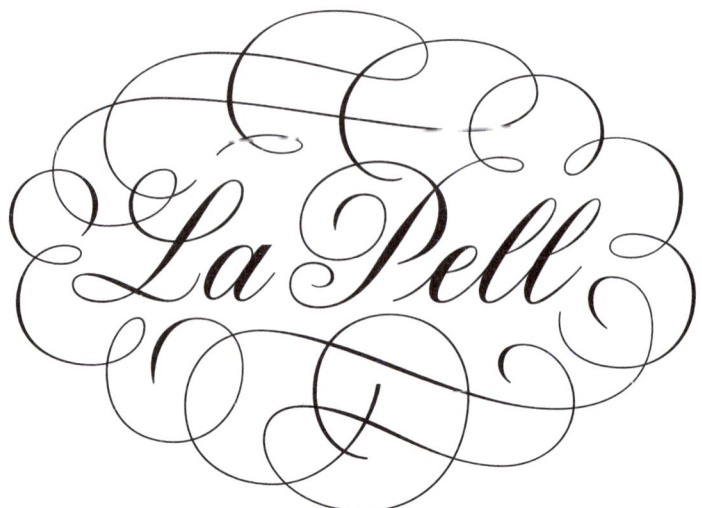

CALLIGRAPHY, LETTERING AND TYPOGRAPHY

3 The alphabet, carved by Nick Benson in green slate using a traditional technique.

4 Jakob Engberg, from Copenhagen Signs, applies textured varieties of gold leaf on glass.

5 Here, designer Alex Trochut has harnessed 3D technology to design a set of numbers.

6 A tattoo by Taioba that uses ornamental calligraphy.

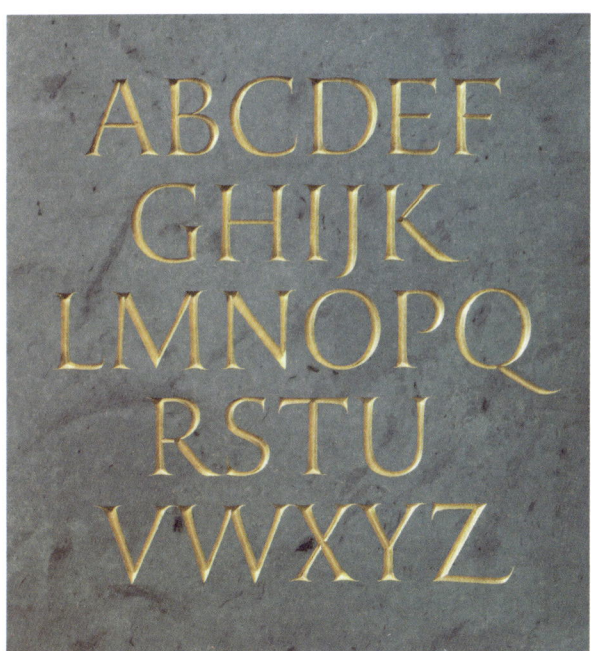

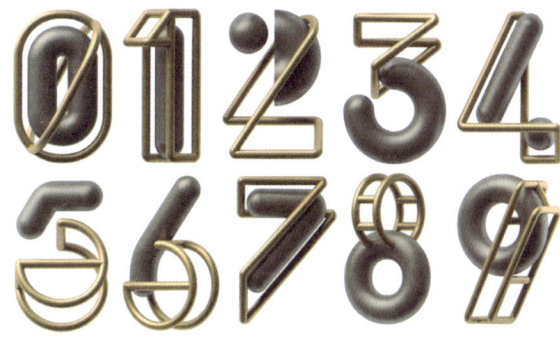

MY LIFE AS A LETTERIST

As you can see, lettering can be a thousand-headed monster where each artist works using a different approach. In my case, drawing letters is my vocation and passion, and I have been lucky enough to be able to make a living out of it. I will briefly explain what my work consists of – not to launch myself into some vain, self-promotional campaign, but because I am assuming that one of the reasons you have this book is because you are interested in how one might earn a living by drawing letters, and in what the daily routine of a calligrapher consists of, other than scheduling posts for social media.

For me, calligraphy is something fairly vocational. As a child I was abnormally curious about letterforms, and when I had the chance I started formal studies with calligraphy professor Keith Adams. Twenty years have passed since then. I suspect that it is important to mention this, since calligraphy is not a discipline that one masters immediately: it requires years of practice. Maybe it needn't take 20 years – don't worry – but still, you don't become a calligrapher overnight!

Esentially, my commercial work consists of designing anything that is to do with hand-drawn letters for visual communication. My clients are design studios, advertising agencies or even the end client of a project, and the work commissioned might consist of a logotype, a title for a magazine article, a book cover, a wine label, a poster, a Christmas card, a mural, an animation, a shop sign, a typeface, socks… well, you get the idea — it could be whatever! On top of that there is also my personal work, within which I investigate and experiment with different letterforms and techniques which are usually a bit too risky to use in commercial commissions.

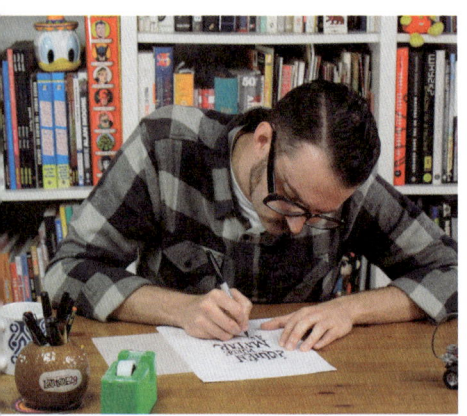

▲ Working in my studio.

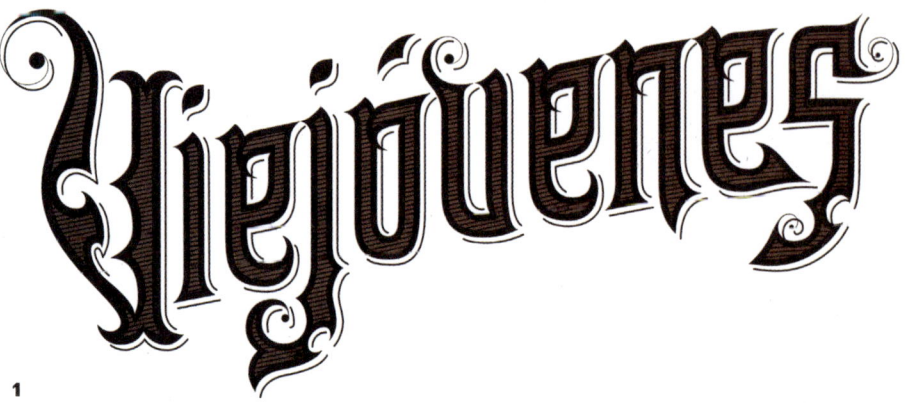

1

Over the last few years I have also dedicated myself to teaching. I give calligraphy and lettering classes to graphic design students, workshops and conferences and even online courses. This book is yet another way of sharing my knowledge with others.

My way of understanding the profession consists of solving a project in the most appropriate way possible, independently of style or personal tastes. Still, since the processes employed are primarily done manually, it is inevitable that there is a certain stylistic continuity across the work I produce. However, this is mostly a result of my attitude towards letter-forms rather than my intention. But let me be clear in saying that this is simply my way of working and of approaching commissions, and it is definitely not the only way. Other lettering professionals approach their work from a much more personal perspective and with a personal style that is much more pronounced.

In the following pages we will cover some of my favourite personal work, and I will explain something about each one. As you will see, the work uses a variety of different techniques and solutions.

1 A logotype inspired by the Victorian style for *Viejóvenes*, a comedy show.

2 A poster for a music festival, created in collaboration with Eva Sanz.

3 A calligraphic experiment based on a Gothic script.

2

3

4

5

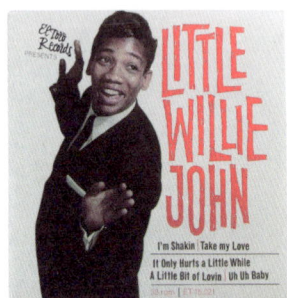

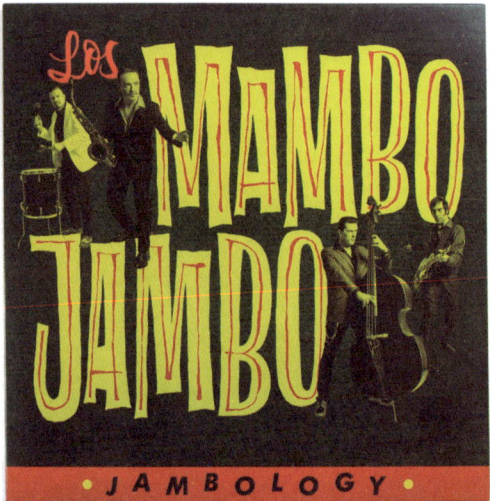

6

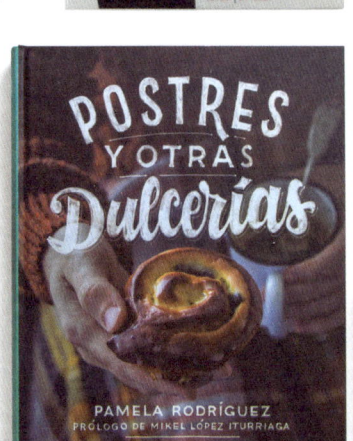

7

8

9

4 Logotype for a photographer, inspired by the Victorian style.

5 Logotype for an exhibition at Los Angeles gallery La Luz de Jesús.

6, 8 Cover artwork for two rhythm'n'blues records.

7 Cover artwork for a desserts cookbook.

9 Title for a book about illustration. Designed by Pixelbox with a background by Juan Díaz-Faes.

10, 11, 12 Various logotypes: for a cinema director, a sangria brand and a tropical cocktails brand.

13 Display window for Sr. Lúpulo, a shop that specializes in craft beers.

14 Sock design for Parachanclas!

15 T-shirt design for Ilustrashop.

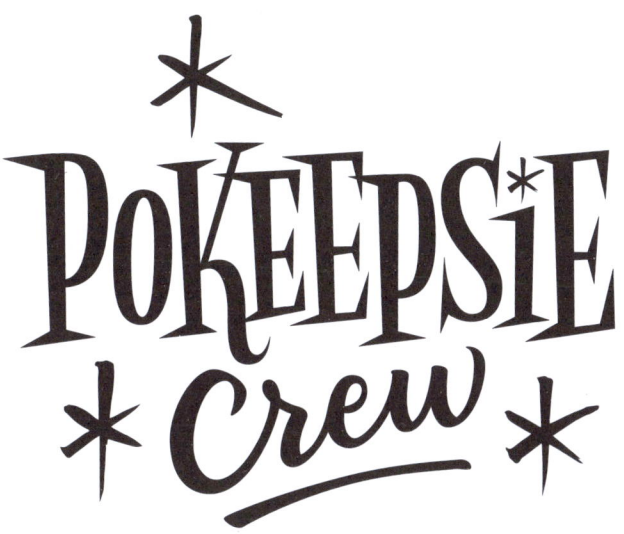

10

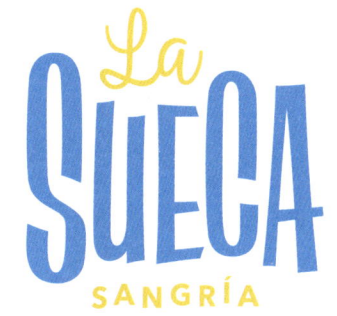

11

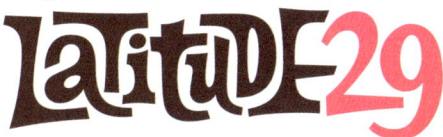

12

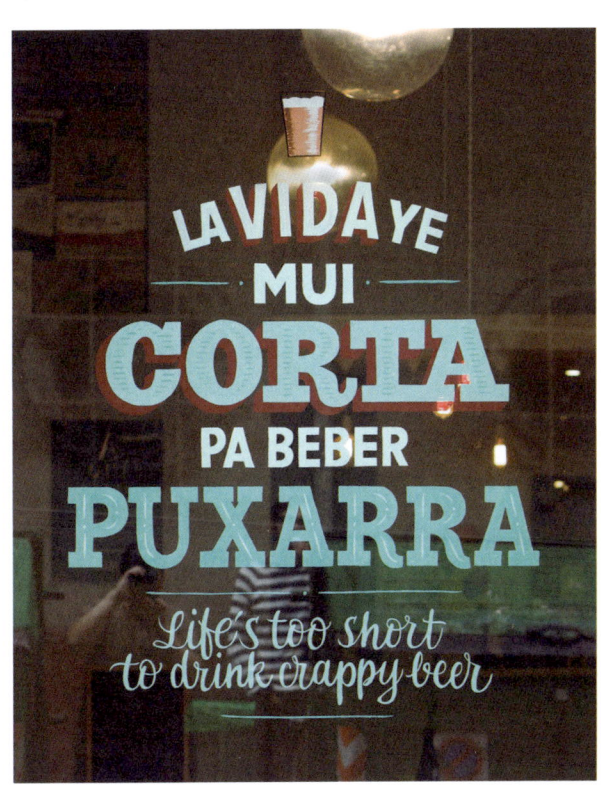

13

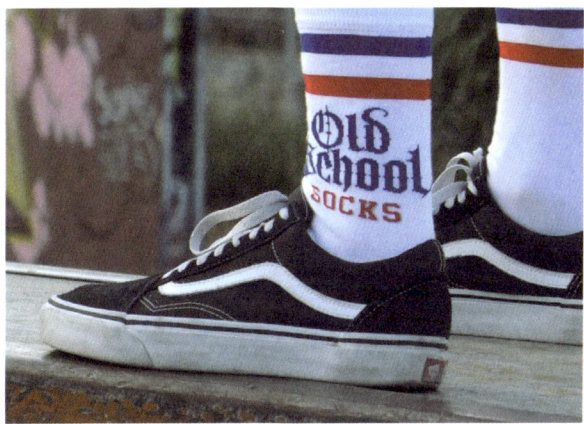

14

15

16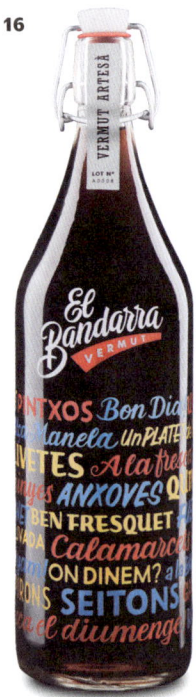

17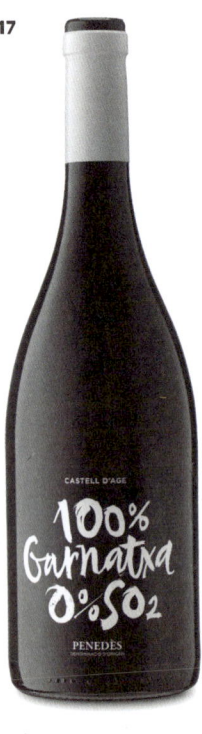

16 Design for a vermouth bottle, which harks back to traditional bar display windows. Produced in collaboration with Albert Virgili Hill.

17 Wine bottle label for Castell d'Age, in collaboration with studio Dorian.

18 A sequence taken from my online course Lettering de Cine on Domestika, in which I create a movie title.

19 Front cover for The ABC of Custom Lettering, my "other" book about lettering.

20 A calligraphic composition for the exhibition Caligrafía en Arantzazu.

18

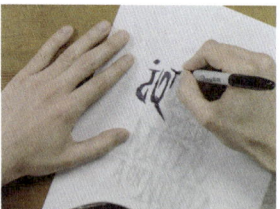
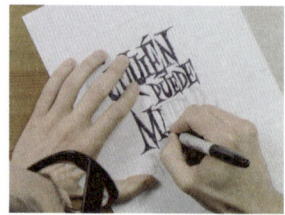
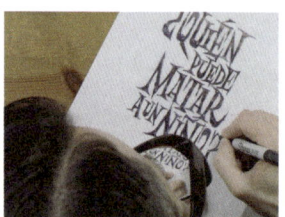

19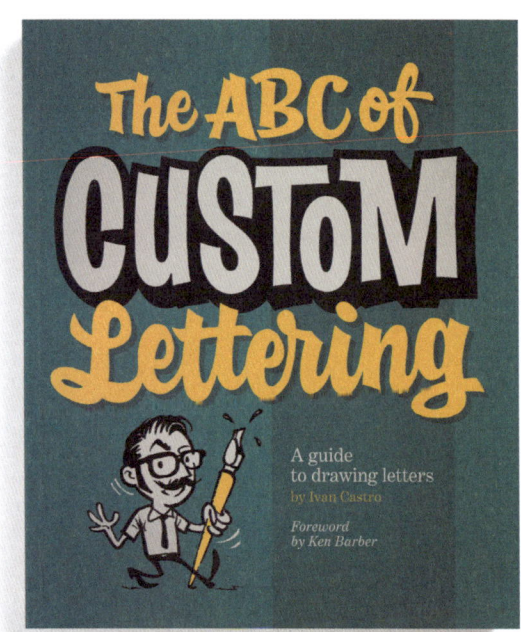

20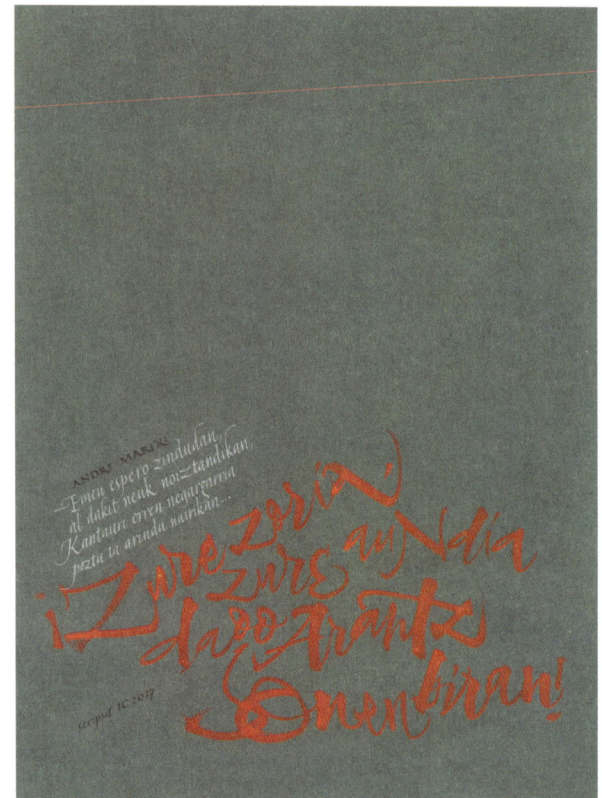

TOOLS AND MATERIALS

There are a multitude of tools available for calligraphy, but we will not need anything remotely specialized to start our lettering exercises, just simple drawing utensils that you probably already have at home.

In the last part of this book, where I will walk you through a series of lettering projects, you will encounter techniques in which you will apply concepts learned earlier. At that point I will mention a few other materials that are needed for specific techniques, but which we will not need in the first part of the book.

I will list the brands and models that I use, but once again, in some cases this is just a personal preference. If you try other tools that work better, then go ahead and use them. If you already own products similar to those mentioned, you do not need to purchase all that I list in the book. Unless, of course, you are one of those people who like to buy drawing materials compulsively – a habit which I not only understand but indulge in and applaud! Anyway, let's crack on.

Pencils. Generally, we are after pencils that allow us maximum precision. Therefore, we need to go for harder graphite (2H, for example) and avoid the softer ones (from 2B upwards). With regard to clutch pencils or traditional ones, I find both work well. I use clutch pencils simply because they are always sharpened. Staedtler® Mars Micro 0.3 is my primary option as it is cheap and easy to find, but there are dozens of other brands. If you have a good sharpener and the habit of using it often, then wooden pencils are just as good.

Erasers. We use two types of eraser — normal ones of a high quality such as Staedtler® Mars Plastic, and a pencil-shaped eraser for editing details with more precision, such as the Tombow® Mono Zero.

Markers. Here is where it gets a bit more complicated. We typically need two types of marker — fine ones and those of medium thickness. The fine ones are used to shade in drawings in a controlled and fine manner. I recommend using calibrated markers: one at least 0.2 mm and another at 0.8 mm. Plenty of brands have models that work just fine. When it comes to thicker markers, it is important that they are permanent, and that they work well on the paper you will be using. One brand that I heartily recommend is the American Sharpie®, specifically the Twin Tip model, which you can easily use to fill in most of your letter work. If the stationery shop next door does not stock them, you should have no problem tracking them down online.

Brush. Although this book is about lettering, we will be doing a little calligraphy work using brushes. For this, we will use a fudepen – a writing pen that has a brush point and can be filled with ink, similar to a fountain pen. There are endless varieties of calligraphic brushes, but they can generally be divided into two types: those with natural hair-based tips, and those with flexible, fibre-based, marker-like tips. I recommend using those that have natural tips as they generally give a much better result than the synthetic ones. Of all the brands on the market, Pentel® is my clear favourite, not only because they are easy to find but also because they work best. For starting out, the Color Brush model is ideal, and if you already have good brushwork skills the Pocket Brush model will be your best friend.

Paper. We will use two types of paper. The first is regular paper for sketching and drawing – regular white, 90 gsm, A4 or letter size paper works great when using pencil, even if there are a multitude of other options you can use when a project requires something of a higher quality. For practising calligraphy with a brush, "laid" paper of 90 gsm, or even sketch paper, will work well. The second paper is a translucent paper which you will use to trace and redraw your sketches. The best is parchment paper, which is similar to baking paper but is thinner, has a texture that is good for pencil work, and is also cheaper. Buy an A4 cartridge of this. If you cannot find any, tracing paper can work fine as a last resort.

Rulers. A set square and a protractor of around 25 cm can be useful when it comes to drawing guides and composition sequences. I have to admit that I myself do not typically use these rulers for drawing or for filling in letters. I believe that they limit rather than help us, making our drawings look more rigid. However, there may be some cases — dealing with a style that is highly geometrical, for example — when using a ruler might make sense.

TOOLS AND MATERIALS

21

Here are a few of the materials mentioned in the text: I utilize these on a daily basis.

1 A 0.3 mm clutch pencil and a 2H pencil. I must say that as romantic as it is to use wood, one is more likely to see me using my clutch pencil.

2 Erasers: a standard one and a Tombow® Mono Zero, for erasing tiny details.

3 Two markers: a Sharpie® Twin Tip (the tip is actually quite fine) and a 0.05 tip pen for very fine details.

4 Pentel® Pocket Brush (above) and a Color Brush (below). The first allows for more detail, while the second is easier to use if you are just starting out.

5 Parchment paper; this is transparent, although that is not evident in the image.

6 Regular white paper of a 90 gsm thickness.

7 A set square and protractor ruler set.

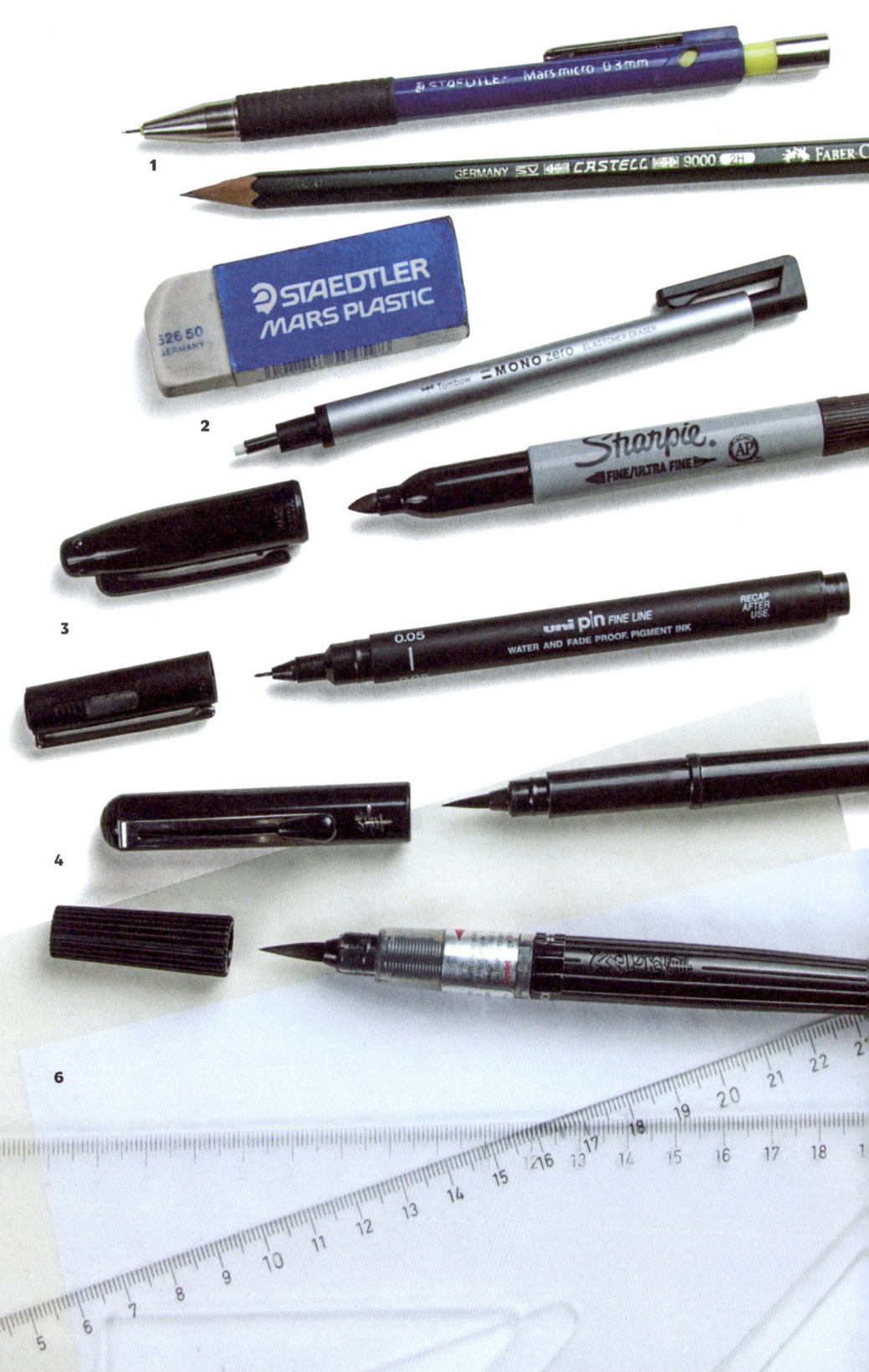

Basic PRINCIPLES

For this chapter, it would have been easy for me to create a compilation of good-looking, easy-to-reproduce letters, ask you to copy them and the way they are composed, and in this way we would both be instantly gratified.

Well, it would be great if lettering was *that* easy to get into, but the bad news is that it is not. Maybe this is a good time to let you in on a secret: lettering is not about copying letters. It is not even about knowing how to draw or using your hands. Lettering, as I hinted at earlier, is more of a cognitive process than a manual one. Due to this, this chapter is probably be the most important in the book.

In the following pages we will see which rules we need to be aware of when starting out in a career as lettering artists. We will study elements such as the basic structure of alphabetical signs; how to give body to these structures; and drawing techniques and the rules of composition – be it for single words or more complex arrangements. We will also go through some different strategies that are good to know when commencing a lettering project.

With this in mind, I would like you to understand that this book is not about the shapes of letters, but rather about why letters have the shapes they do, or why we create a composition in one way and not another, or even about which resources to use for finishing off our work – information which will help us take logical and calculated decisions. Familiarizing ourselves with these standards is what will make our projects stand out, unlike the poor imitations that we often see on social media.

Of course, learning how to recognize the good from the bad is vital. We achieve this by understanding the correct way of doing things, so we can avoid basic errors. Sometimes, we see artists who break the rules and seem to do everything contrary to standard practice. That is all well and good when the rules are broken by someone who knows them. But if we do the same, we run the risk of coming across as amateurish, rather than innovative or groundbreaking.

Therefore, I ask you – and your brand new materials, which are dying to make a debut – to have just a bit more patience. Leave the materials to one side and read this chapter calmly before setting out to draw. Well, alright, perhaps you can brandish a new pencil or two when practising some of the concepts we will be covering. But, I insist, it is of vital importance to get a good grasp of the fundamentals of lettering before putting yourself to the task. If you already have a vague understanding of lettering, then this chapter will serve to clarify any doubts which you might still have. If, on the contrary, this is the first time you are venturing out into the world of letter drawing, then having things clear right from the start will save you a few headaches later on.

A HISTORY OF CALLIGRAPHY FOR DUMMIES

It probably won't come as a surprise to you when I say that the sheer variety of letters in existence is practically infinite. The few pages since the start of the book should have made this more than evident, but rest assured that these are just a tiny fraction of the possibilities chosen from an entire universe of letterforms.

What is not so obvious, perhaps, is that when we simplify any letter down to its primary structure, we will notice how all letter styles essentially belong to one of three basic morphologies: minuscule Roman, minuscule cursive, and capital letters.

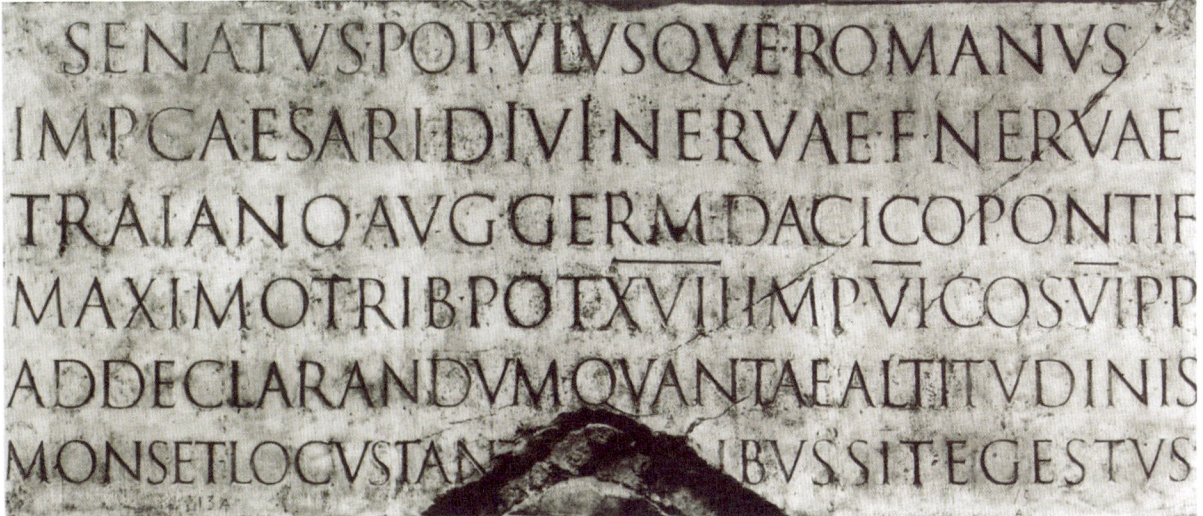

▲ This is the inscription that appears at the foot of Trajan's Column in Rome. Despite the existence of hundreds of other exemplars of Roman plaques, this is the one which is considered to be the archetype of Roman square capitals.

Unfortunately, too many things have happened since the day someone scrawled some signs onto a clay tablet 6,000 years ago in Mesopotamia, making it impossible to give a detailed account of hand writing history in such a short chapter. Nevertheless, the three morphologies that I have just mentioned should provide us with enough context for understanding their importance. Keep in mind that for the sake of obtaining a good *impression* of the concepts behind lettering, a brief wade through history should be more than enough at this stage.

A good way of thinking about the history of lettering is by visualising it as a natural evolution that has been punctuated here and there by issues related to culture, politics and religion. It is actually these punctuations that have proven to be the most influential factors over the legacy that has lived on to this present day.

The Latin alphabet was invented in classical Rome, which in turn was based on the forms and writing system of ancient Greece. The Romans had a range of writing styles that were used depending on the intention of the message. We have all heard of wax tablets and the stylus, both of which were part of everyday use, but in fact this was a style of writing that did not make it to the present day. The same thing befell the "rustic capitals" system, a quick and ephemeral writing style which is not around anymore but which can still be admired amongst the ruins in Pompeii, Italy. On the other hand, I am sure it is not too hard to visualise those classic capital letters which we associate with Rome — the ones that were used for engraving commemorative stone plaques and which we refer to as "Roman square capitals". It is this set of letters — with their classical proportions and form — that has transcended history to become the absolute standard for uppercase letters.

▲ The Ramsey Psalter. British Library, ref. Harley Ms. 2904, f.201 v., detail. Reproduced at its original size. A fantastic example of a late-British Carolingian work which, apart from being historically significant, also allows us to see the relation between 10th-century script and the current one.

▶ Apologues by Pandolfo Collenuccio. British Library, ref. Royal Ms. 12. C VIII f.2 v., detail. Reproduced at twice its original size. Written in 1517 by Ludovico degli Arrighi, this is an example of classic Italics from the 16th century. When compared to the Carolingian example, we can appreciate the differences in the inclined, angular and stylised forms.

Further down the line, we arrive at a point in 313 AD where Emperor Constantine I declares Christianity to be the faith of the Roman world. A decision was taken to create a new script which would distinguish new Christian Rome from old pagan Rome. This alphabet is called Uncial, and it is by and large characterised by the introduction of more rounded forms. Even if it was not exactly a minuscule script, it started the process of breaking with standards such as the rigid baselines and capital heights that were used by Roman square capitals.

Fast-forwarding to the 5th century AD, we come to what is now considered to be the fall of the Roman Empire, during which political, economic and cultural unity dissolved into a patchwork of different entities. Each one of these entities went on to evolve in a distinct manner, with differing characteristics. The Latin language branched off into the different languages we know of today, and writing systems also diversified. For example, the British Isles saw the evolution of the so-called Insular half-uncial script, while Visigothic flourished in the Iberian Peninsula. The territories we now know as France and Italy gave rise to the Merovingian and Beneventan scripts respectively.

The year 800 AD presents us with yet another milestone. By now, Emperor Charlemagne had conquered a vast chunk of continental Europe and established the Holy Roman Empire. Despite his reputation as a military general, he was also conscious of the fact that he needed a common script with which to unite his vast empire. A British academic, Alcuin of York, was appointed to create a new script; it was based on the rounded forms of the Uncial script (from which all later scripts were developed), but was simplified to aid its execution and legibility. This script came to be known as Carolingian (from *Carolus Magnus*) and went on to become the basis for the development of the current lowercase typography system.

As the Middle Ages unfolded, Romanesque art gradually gave way to the Gothic, and the same thing happened within the writing world. The Carolingian script, with its rounded forms and proportions, became increasingly narrow and angular until it turned into the Gothic letterforms which we today associate with the Middle Ages.

The 15th century saw the emergence of a cultural revolution in Italy that we call the Renaissance, and here we find yet another milestone. Part of the great change that happened during this era was a rejection of medieval art and a return to classical artistic concepts. With the revival of these canons of antiquity came the return of Roman square capitals and the Carolingian script, the latter brought back to life precisely for its open and rounded forms that many considered to be more legible than its Gothic counterpart.

The Renaissance oversaw a democratisation of culture which led to an uptake in literacy amongst the people. Writing became increasingly widespread, which in the process popularised calligraphy. This new situation gave rise to a new way of writing that used one continuous stroke for writing, making it faster and more practical. This meant that, if drawing the letter *a* required two strokes in the Carolingian style, the new system — called Italic — used just one. This was applied to all letters in the alphabet.

Therefore, this makes the Italic system the basis for all *cursive* typefaces. It is worth making things clear at this point, so allow me to explain. When we say cursive (from the Latin *cursus*, which means "running"), we are not referring to the inclination of the letter but rather to the act of writing in a flowing, connected manner. It might be true that writing at an increased speed could cause the letters to lean forward slightly (which is what links Italic and cursive), but generally speaking the word cursive refers to letters of a continuous structure.

The 16th century was a watershed moment for calligraphy in Italy. During its first half, various important treaties about calligraphy were published by masters such as Tagliente, Arrighi and Palatino. From then on, and in part due to the democratisation of print, calligraphy went from being a system used to reproduce texts to a more decadent art form, one which gave preference to decoration over legibility. Over time, traditional calligraphic techniques were lost, until an effort led simultaneously by Edward Johnston in Britain and Rudolf Koch in Germany at the start of the 20th century single-handedly revived calligraphy to an art form that is nowadays as popular as it has even been.

THE IMPORTANCE OF STRUCTURE

I want to conclude the previous chapter and open this new one with the following idea. As I mentioned at the start, the three scripts which over time came to define the shapes of the letters that we use in our everyday life are the Roman square capital, the Carolingian and the cursive Italic. What should interest us most about them here is not their history but their internal structure.

As we will see later, many factors can determine the way a letter is formed – weight, proportion, contrast, aperture, serifs etc. – but without a doubt, the thing on which all of these elements hinge is the structure. Here is a comparison: when modelling a solid figure out of clay, we use a skeleton made out of metal wire to help support the figure. Even after adding and modelling the clay to our liking, it is this internal skeleton structure that in reality determines the eventual shape of the figure.

Therefore, if we reduce the Roman square capital, the Carolingian and the cursive Italic down to their essence, even ignoring calligraphic features that might have come about with the use of a flat-nibbed writing tool, we are left with models of basic letters. These are incredibly helpful in helping us understand what an archetypal letterform looks like. I have prepared the following models by reducing the original letterforms as much as possible and converting them into structures which are as neutral as can be.

My advice for taking the first steps in lettering is for you to absorb these schematic structures before attempting to master more complex ideas. Drawing and redrawing these alphabets will help you understand the proportions and the forms of each letter. This knowledge will play a crucial role later on, when working on bigger projects. Of course, this does not consist of simply copying the alphabets, but of understanding and really grasping these letterforms. Using a pencil and the cleanest, most controlled stroke possible, try to draw words and phrases in the style of these structures. Later on we will see how we can bring these rather skinny-looking characters to life.

THE IMPORTANCE OF STRUCTURE

MINUSCULE ROMAN

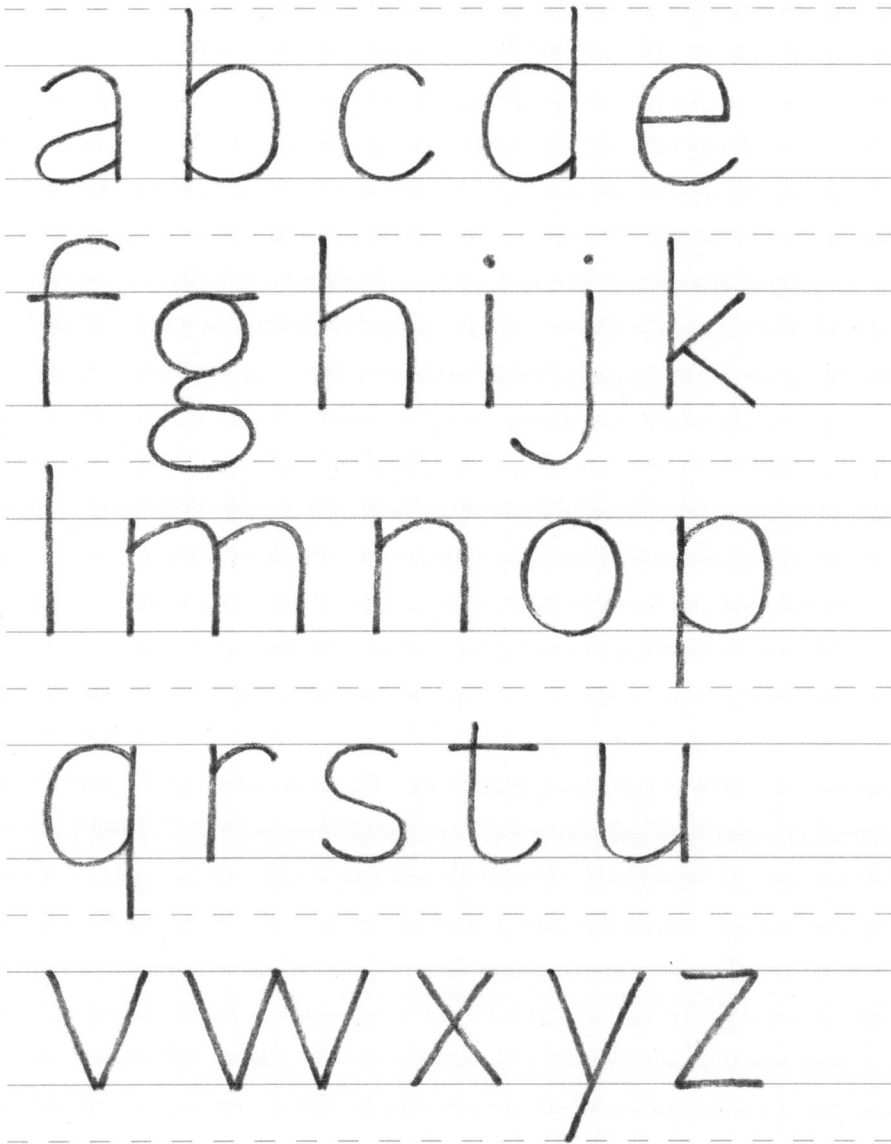

• This is a generic alphabet structure. As we will see later, it is begging to be modified. Still, it is a good idea to start by studying this model so that you slowly get accustomed to working with these forms.

• For the most part, letter shapes are rounded. The letter *o* is obviously rounded, but observe how the shoulders (curves) of the *n* and *m* are also rounded. The overall dynamic between the letters is also incredibly important. For example, the *n* and the *u* are the same shape turned 180°. Similarly, the shoulders of the *m* and *n*, which have the same shape, are repeated in the bowl-shaped *p*, *q*, *b* and *d*. Perhaps less obvious is that the upper curve of the *a* has the same shape as the shoulder of the *n*.

• Notice how the proportions are equivalent for all letters. The *n* is the letter that is used as the basis for the rest of the alphabet. All letters have the same width, except those which, for obvious reasons, are wider – such as *m* or *w* – or narrower for reasons of optical correction, such as *r* or *t*. We will speak more about these optical corrections later on.

• This model only covers the anglophone alphabet, omitting characters from other languages such as ñ or ç. In reality, I do not consider such characters to be necessary for this book, since here we are dealing only with the basics of the alphabet; and after all, an ñ is just an *n* with a punctuation mark on top.

MINUSCULE CURSIVE

abcde
fghijk
lmnop
qrstu
vwxyz

Apart from some similarities with minuscule Roman, we can identify some clear differences when dealing with cursive.

• A continuous stroke determines the structure of cursive letters. Observe how the letter *a* can be written in a single stroke, unlike the minuscule Roman *a*, for which you need two. This pattern can be applied to most cursive letters.

• In contrast to the roundedness of minuscule Roman, the cursive has a more angular structure. Here, the form of the shoulder of the *n* is asymmetric, unlike the Roman *n*. This form is a result of it being written in a continuous stroke. It is important to understand that here the form is determined by the gesture and is not simply a question of overall form or shape.

• Another factor to consider is the inclination of the letter, as opposed to the vertical orientation of the Roman. The model on the left is a generic one, and its inclination can be made to be less or more accentuated.

• Something similar occurs with proportions. On the whole, a cursive is narrower than a Roman, but there may be exceptions.

THE IMPORTANCE OF STRUCTURE

ROMAN CAPITALS

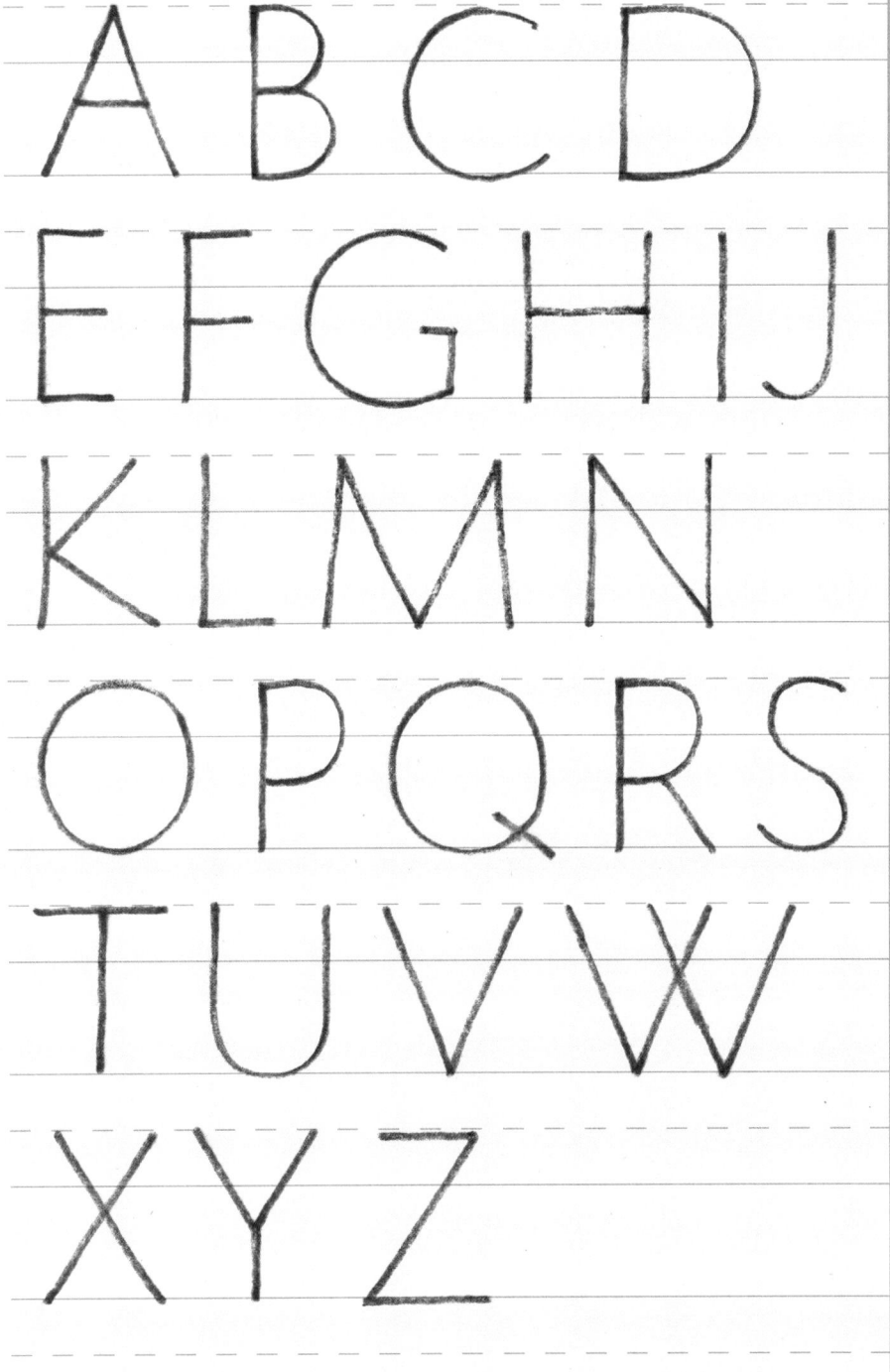

- The main idea to keep in mind when studying Roman capitals is its proportion. As you can see, the ratio between the height and width can vary widely depending on the letter.

- We can establish three groups of letters based on their proportions. Rounded letters (C, D, G, O, Q) have an equal height and width, resulting in a 1:1 proportion. Another group of letters, including those with diagonal strokes (A, H, K, N, T, U, V, X, Y, Z), are somewhat narrower, with a proportion of 4:5. Finally, we find another group (B, E, F, J, L, P, R, S) with a noticeably narrower width, around 1:2, which means that the width is half the height. Some letters, such as M, I o W, as you can see, defy categorisation.

- This proportion is typical of classical Rome. While we consider these proportions to be part of the classical canon, we might encounter uppercase alphabets that are not governed by these proportions.

- We may accompany this model of capital letters with minuscule Roman. When accompanying them with minuscule cursive, the forms remain the same but adopt a similar inclination.

BASIC PRINCIPLES

▶ **EXERCISE**

I have based this composition on the alphabets that we covered in the previous pages. Look for a piece of text of a similar type that contains various elements, and have a go at making your own composition.

Using a hard pencil, start by sketching some guides, which will help align and keep your letters at a constant height. After, using a soft pencil, draw your letters in the cleanest way possible.

The aim of this exercise is as follows:

• To get a feel for the letterforms, keeping in mind the factors we mentioned earlier – proportions, forms, relationships between letters, etc.

• To observe the differences between the different structures and how they can be combined. Notice how the combination of Roman and cursive or capitals and minuscules work together.

• I have purposely included some rules of composition about which we have not yet spoken. When doing this exercise, just let yourself draw intuitively for now, and we will get to how to organise information later on.

SIR Ian McKellen
AND
DAME Judy Dench
STAR IN

MACBETH

BY William
 Shakespeare

THE Royal Shakespeare
 Company PRODUCTION

THE ANATOMY OF A LETTER

Before we march on, maybe it is time to get familiar with some typographical terminology – from now on, things will be getting a bit more technical. Have a look at the illustration below, in which I have marked out and named the different parts of a letter. It is not necessary to memorise them, but it will be helpful for you to know what I am talking about when I use words such as *ascender, serif* or *terminal*. It will also be handy to get to know the different lines used to define letter heights.

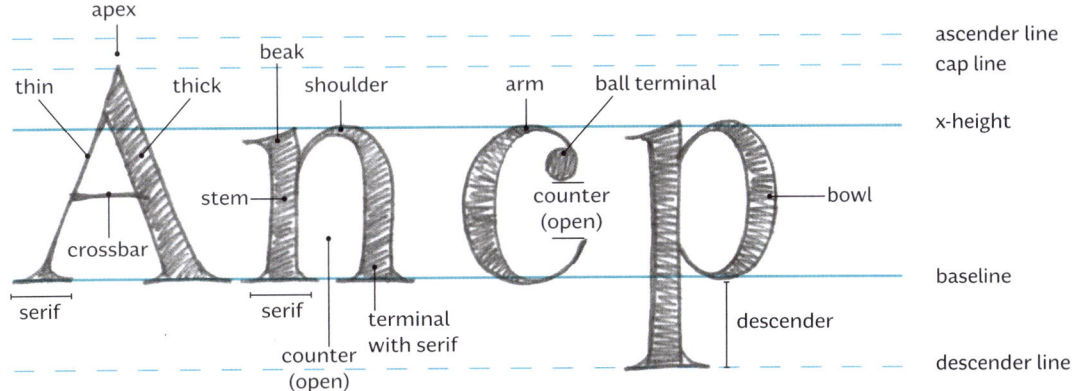

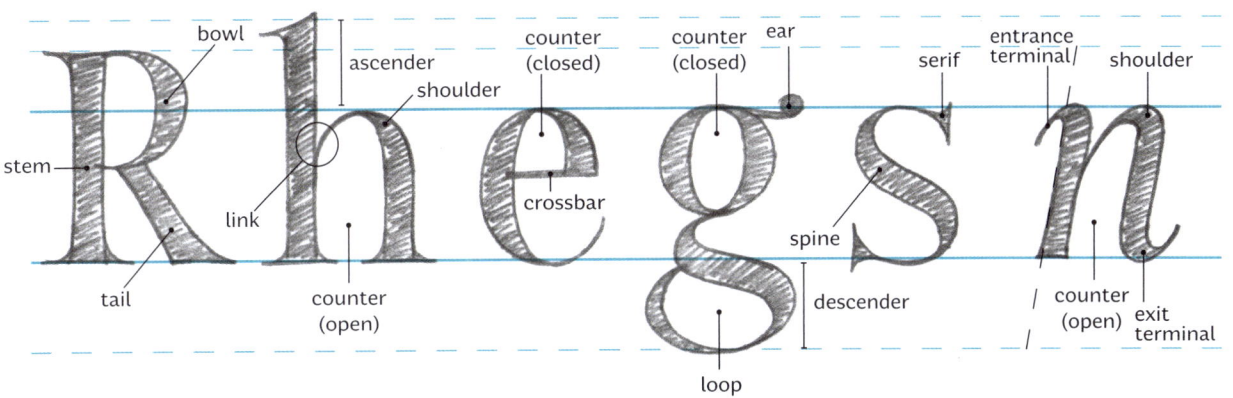

VARIABLE FACTORS

Until this point, we have used neutral letterforms that have been stripped of any qualities that might give them personality and which were reduced to their essential structure. But this is just the entry point to understanding the world of letterforms. A combination of variable factors will determine the final form of a letter. When dealing with our own lettering projects, we will need to decide how to use these factors to obtain the desired result.

▶ **PROPORTION**
The structure of a letter can be wide or narrow. An *n* that is slightly narrower than its height is considered to be the medium point between the two, but we can always change these proportions.

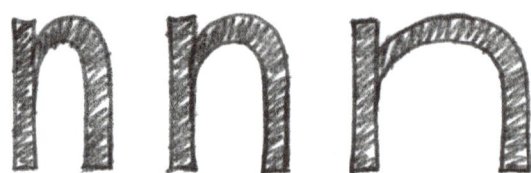

▶ **FORM**
We usually associate rounded forms with a Roman and angular ones with a cursive, but we can always choose to do the opposite by applying angular forms to a Roman structure and vice versa!

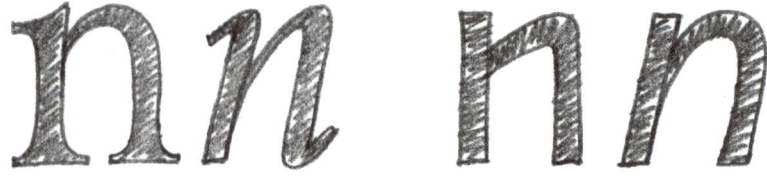

▶ **CONTRAST**
Contrast refers to the differences in the width of a letter's stroke, which can be thicker or thinner. Additionally, contrast can be softer or more abrupt. In the last two letters, the difference between thick and thin is the same, yet one example is more abrupt than the other.

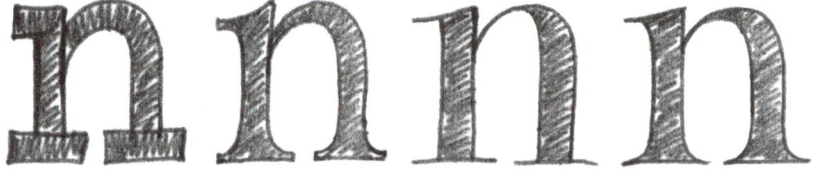

▶ **INCLINATION**
We've seen models of both lowercase Roman and inclined cursive; however, in a similar way to what happens with form, it does not always have to be this way. *Inclined* and *cursive* do not mean the same thing!

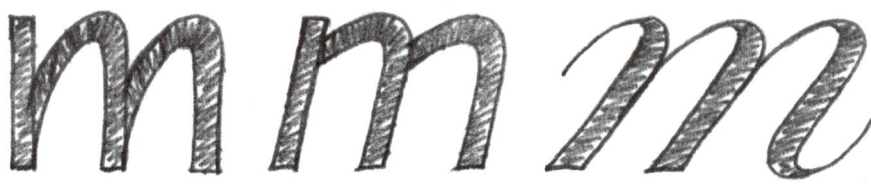

VARIABLE FACTORS

▶ WEIGHT
This refers to the thickness of a letter. As you can see, even by maintaining the same internal structure, a letter can be thicker or thinner.

▶ AXIS
In typography, the axis is an imaginary line that links the extremity of one letter to that of another. We have two types of axis: oblique (or *humanist*), and vertical (or *rationalist*). Axis and contrast are intimately related; we will discuss these further in the following pages.

▶ TERMINALS
The terminal of a letter is the endpoint of its stem. It can take the shape of a serif, a ball (or drop), be curved, straight, oblique… there are innumerable options. The terminal plays a vital role in the way the eye perceives letterforms.

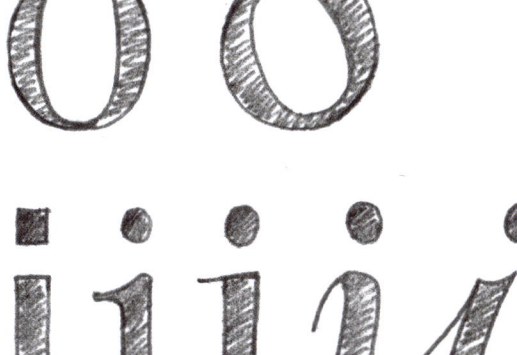

▶ SERIFS
When the terminal ends in a serif, this can take various shapes and weights. In the illustration are different examples, from formal to more expressive. Letters that do not use a serif are referred to as *sans-serif*.

▶ COUNTER (OPEN)
An open counter is white space within a letter that has a partial exit. Depending on the letter, the counter can be made to be more or less emphasised.

BOLD, THIN, AXES AND CONTRAST

When starting out in a career as a letterist (or perhaps even when already established), there is one issue which always causes some confusion and is one of the principal causes of error in the work of amateurs. It consists of knowing – when dealing with contrast – where to place the thick strokes and where to place the thin ones.

The good news is that taking these decisions should not be too hard since there are already established norms which have been guiding letterists since the origins of the Latin alphabet and which depend on the letter at hand. Practising calligraphy will help us understand these norms, but I am going to tell you of a more straightforward way of understanding them, based on the theories of Noordzij.

Gerrit Noordzij is a Dutch type designer who in his 1985 book *The Stroke of the Pen,* introduces a theory that directly links calligraphic script with the order and positioning of thick and thin strokes in typographic design, and this also applies when dealing with lettering.

According to Noordzij, we can arrive at a letterform from two points of view. On the one hand, we can see it from the point of view of the tool that we will be using to write. We can use a flat-tipped calligraphic tool, such as a flat-nib pen or a square-tipped paintbrush, or we can use a

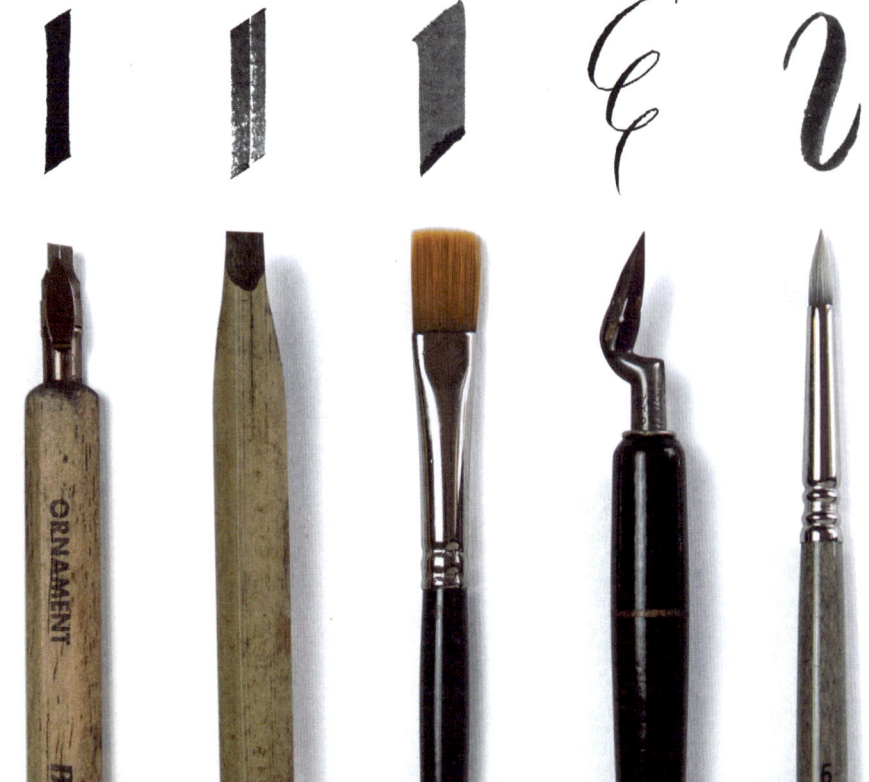

▶ From left to right: a flat nib, a nib made from a bamboo cane, a flat brush, an expansion nib and a round brush. Shown above the tools are the strokes that we obtain with them.

BOLD, THIN, AXES AND CONTRAST

expansion | translation

Roman

cursive

writing tool that "expands", such as a pointed-nib pen or a rounded brush. We call these *expansion tools* because they allow us to vary the pressure applied when writing with them, creating thicker or thinner strokes as we go along. Conversely, when using flat-tipped calligraphic tools, the stroke features are obtained by default during the act of writing. We refer to this particular action as *translation*.

On the other hand, as we discussed earlier, we need to be aware of letter construction. Always be mindful of the difference between Roman and cursive or, in other words, an interrupted letter structure versus a continuous, flowing one.

In the diagram above, notice how the two letters on the left are written with a rounded brush, which is an *expansion* tool, while the letters on the right are written with a *translation* tool, here, a bamboo pen. At the same time, the letters at the top have a Roman structure while the ones below are cursive. Notice how the major differences between the two are in their axes and contrast. We can say that the expansion letters come with an accentuated contrast and a vertical axis, while the translation letters have a more moderate contrast and an oblique axis. The diagram shows us the four extreme typologies, but we have to understand that there are intermediate typologies to be found between these four extremes, which can lead to infinite possibilities.

> ★ *Modulation* is the term we use when we want to describe the difference between thick and thin strokes. It should not be confused with contrast, which is the difference created *during* modulation. The passage from thick to thin can be more abrupt or more gradual – which corresponds to strokes which are *less* or *more* modulated.

We will now try to get a better understanding of the differences between the theories of translation and expansion by seeing how thick and thin strokes are obtained in each case. We will start by creating a continuous structure using an expansion tool (in the previous diagram, the one on the bottom left). When we write, we do so in a motion that goes from top to bottom and vice-versa, repeatedly. With this formula in mind, we can see that when we write from top to bottom we apply a certain pressure to the writing tool, which results in a thicker stroke. When going from bottom to top, we do not apply pressure, and therefore the stroke is thinner.

Conversely, when using a flat-tipped pen, the difference in stroke is not produced through pressure but by the angle with which we handle our writing tool, together with the direction of the strokes. As in the previous diagram, vertical or descending diagonals are thick, while horizontals and ascending diagonals are thinner. When dealing with a circular form, the stroke will vary depending on the direction of our writing.

All of this forms part of a theoretical framework which we need to understand if we are to take the correct decisions when drawing our letters. Despite the calligraphic origins of these principles, we will also need to apply them when drawing letters. Knowing these principles will make our life easier because, as I explained at the start of the book, they will help us decide where to place thick and thin strokes, independently of the style in which we are working.

▶ EXERCISE

This exercise will help you to start utilizing the concepts on the previous pages. Draw the letters *nov* in three different styles: one using a serif and another without, and in the process try to apply some of the things you have learnt over the last few chapters; for the third style, just go as crazy as you can by breaking all the rules you can imagine. Just let it all out and don't be shy!

In the first example, I have taken a Roman structure as a starting point. It is a sans-serif, and has a very low, amost non-existent, contrast. I decided to give it a proportion that is wider than average and a rectangular aspect.

The second option is completely different from the first. Firstly, the structure is cursive and with a very accentuated contrast. With regard to the serifs, I have combined some fine serif terminals with others that have entrance and exit terminals, giving it a calligraphic feel. I have also gone for a slightly narrow proportion.

In the third option, I started by breaking some typographic principles, primarily those which relate to the positioning of thick and thin strokes. As you can see, horizontal strokes are thick while vertical ones are thin. Another unusual characteristic is the complex and decorative aspect of the serifs. As they are quite heavy they allow us to add some ornamental elements. I also decided to add some more ornamentation throughout the rest of the letters, not only in the terminals.

DRAWING TECHNIQUES

While it is true that, as I have already mentioned, lettering is based more on an intellectual process than a manual one, and also that drawing is a tool that we use to give shape to what we have in our mind, it might be a good idea to learn how to do so in the most precise and effective way possible. Here I will be showing you some simple tricks for doing exactly this.

▶ The first letter is drawn with a single stroke and an HB pencil. The second is made with a 2H pencil. It is formed by numerous fine and soft strokes, meaning that even if we don't have such a clean finish, at least the shape is more controlled than in the first drawing.

Do not attempt to draw in a continuous line. If you are starting out with drawing, you might find that when you try to draw a form using one single line, the form contains numerous imperfections that simply make it not look good. Instead of this, try to draw your letters using a series of fine, sketchy lines that slowly add up to make a line. The lines might have variations, and your form might not be *that* sharp or crisp, but the sum of these lines gives you the ideal shape, which is what we need at the early phases of a project. Just as when you take a selfie on your phone and slap on a blurry filter so that everyone focuses on your good features, this will be something along those lines!

▶ The E on the left is drawn according to its outline and without lifting the pencil from the paper. Notice how there are certain irregularities, such as the thickness of the main stem, which is not uniform, or inconsistencies in the forms of the serifs. This is due to the lack of control provided by this method. On the other hand, on the right we see how to draw the letter correctly in three steps: first we create the main stem, then we add the bars and finally the serifs. In this way, we control each part of the letter much better, since we are drawing them individually.

Draw in sections. As we have already seen, letters have a very concrete anatomy. When drawing the "skeleton", just as we did in the opening exercises, we drew each part of the letter with one single stroke. But when it comes to constructing a more complex letter, with a thickness, contrast, serifs etc., the tendency is for the letterform to be drawn in its totality instead of being drawn according to its various elements. In the same way that drawing a human figure requires a good knowledge of human anatomy, with letters we need to be aware of

how their different parts relate to each other. This will help us resolve certain details much better, especially in cases where two distinct elements meet, such as the main stem and the shoulder or arm, or a stem with a serif, or internal counters. Therefore, do not simply draw all of the outline of a letter, but rather, construct the letter bit by bit, as if you were writing it. This process should be used at any stage, from initial sketches all the way to your finished inked work.

◂ As it stands, the example on the left is more of an abstraction of the real form of the letter, which we cannot really appreciate until we fill it in, as in the example on the right. As you can see, it is not too important that the shading is clean or technically perfect: it is enough to help us see how the letter will behave.

When you have your final form, fill it in. While it is true that the outline defines the final shape of our letters, the outline on its own does not give us a good idea of the *weight* of our letters. This makes it difficult to gauge the rhythm of the letters, as we are not seeing the actual letters but a sort of sketchy version of them. So, when your letters are more or less finalised, shade in and fill the space inside the outline so that you get an idea of the letter structures and how they might look when they are finally painted in.

Start small, finish big. When starting on a project, there is a tendency to sometimes create big sketches, as we think that doing so might give us better control over the result, and may even help us better define details. Even if starting big appears to give us better control of details, this is a common misconception, as what we need to do at this stage is get a feel for the overall rhythm and form of the word, without going into so much detail. We are used to reading and writing at a small size. Therefore we should also try to sketch at a small scale (more or less the size of the palm of the hand), as it will come to us easier. We should be able to fit five or six sketches onto a standard A4 page. Once we have chosen our favourite sketch, we can amplify it by using a photocopier or scanner and a printer to print it out and trace it.

BASIC PRINCIPLES

Inking starts from the outline and goes inwards. So far we have worked with a pencil, but let's face it, you will have to get your drawings inked in at some point. Inking has the advantage of making your drawing cleaner and better finished, but that will only happen if you do it accurately, calmly and with attention to detail. While a vague or irregular sketch can result in something interesting when using a pencil, inking is somewhat less forgiving: it is either black or white.

To ink accurately, you must start by going over the outline of the letter (or rather, each of its parts) with a fine marker. Sometimes, when I want a lot of detail, I do this with a 0.05 mm pen so that I can have the sharpest finish possible. If a letter consists of intricate details – pointed serifs, for example – you can also fill them in with this same pen. Once we have defined the shape, we fill it in with a thicker marker, taking care not to overshoot the outline we have just drawn. The most delicate shapes are typically drawn with a thinner marker to control the detail, and a thicker marker is used for parts that do not require so much precision. It is common sense!

▼ Notice the different steps when inking in this letter N, starting with the original pencil version on the left. Placing some parchment paper on top, I started tracing its outline with a 0.4 mm calibrated marker. I used it again in the next step to fill in delicate and sharp angles, in this case, the sharp serifs. Finally, I filled in the rest of the letter with a thicker marker.

DRAWING TECHNIQUES 43

◀ The three steps of a sketch. The first sketch for this *abc* is on the far left. As you can see, it is quite small, and it does not allow me to control the detail very well. However, it does allow me to control the rhythm and the general shape of the letters. In the next step, I used a photocopier to blow up the original by 200%. Lastly, I redrew this version. Working larger, and seeing that the structure of the initial sketch was already working very well, I was able to pay more attention to detail.

Work in layers. From the first sketch up to the final inked piece, our letters go through a series of phases, each time being improved, corrected and polished. Of course, we do not carry out all of this on the first page, but separately and by applying one change at a time. Use parchment paper (or tracing paper) to draw on the sketches without having to erase the previous steps. This way the work will be cleaner and faster, and we get the bonus of saving previous versions of the work, in case we have to revisit them – you never know.

▼ A small sign, from its first sketch – shown on the bottom-most sheet – to the final drawing, in ink. As you can see, every step is done on a new sheet of parchment paper, each time redrawing and improving the previous drawing.

RHYTHM, SPACING AND FORM

Up until now we have been dealing with content that is related almost exclusively to letterforms. Nevertheless, we need to be aware of the fact that individual letters are not our objective here as they do not have any value unless used to compose words, which in turn are used to form a piece of text. So, let's speak about some things which are worth knowing if we want to construct words.

British type designer Matthew Carter is the author of a phrase that typography teachers love to quote: "Type is a beautiful group of letters, not a group of beautiful letters". When we form a set of letters, regardless of whether the letters are pretty or not (this is something very subjective and rather unimportant), we have to make sure that it has good rhythm. By this I am referring to a set of factors that are not directly related to the letterforms and which, as a consequence, are often overlooked by beginners (and even by more advanced practitioners). These factors allow us to see a word as a uniform whole and not solely as a bunch of beautiful letters that appear side by side.

Spacing. In lettering, we do not work just with the mass formed by letterforms. The white space around the letter is as important as the letter itself, if not more so. This space is what allows us to distinguish the shapes of letters and to be able to link them visually. It might help us to think of white space as a frame around our letters. It should not come as a surprise that within a word, the space between letters must be uniform, i.e., always the same. This idea is easy to understand as a concept, but in reality, applying it can be a slightly trickier business.

The first thing we need to understand is that space and distance are not the same. Let's look at the diagram on the next page, in which there are three geometric figures: a square, a circle and a triangle. The distance between them on the horizontal axis is always the same: nil. In spite of this, the space we find between the figures is variable. Between the square and the circle, there is little space, while the white space between the circle and the triangle is much larger. If after this sequence we placed another triangle, it would leave an enormous space, while another square before the first square would leave no white space at all. Still, whichever sequence we use, the distance would always remain the same. This is because each shape comes with a different surrounding white space, as defined by its form.

RHYTHM, SPACING AND FORM

◀ Notice how, despite the minimal distance between the figures, the white space between them (marked in the drawing in blue) is very irregular. This clearly shows how distance and space are two concepts that, although related, are not necessarily equivalent.

These three simple forms are merely a simplification of possible letterforms. Although more complex, letters generally behave in the same way, which is to say, each one leaves around it a white space of differing shapes and sizes. In order to have uniform spacing, we must make this space the same throughout a word. Since the white space between each pair of letters will be larger or smaller, we will have to adjust the distance between them so that the white space is similar. It is also important to understand that this calculation is done visually. So, before you get any ideas about drawing a box for each letter and leaving the same distance between them, in the hope of achieving white space perfection, let me warn you that this will not work.

Notice the combination of the letters *nov*, where we have three forms similar to the geometric figures shown in the previous scheme. For the white space between them to be equivalent, the pair of letters *no* should not have more distance between them than *ov*, since in the latter, the *v* automatically provides this extra space.

The Latin alphabet is a writing system that leaves space, both around letters and within them. The white space *between* letters must be the same as the one *inside* them. Theoretically, within each of the letters *n, o* and *v,* the white space occupies a similar area, despite them having different shapes. Therefore, the white space between them must reflect a mass similar to the interior one. This implies that if the letters we are working with are heavier, or wider, or possess any other characteristic that affects the internal white space, it will affect the white space that we should leave between them.

▲ On the left, we see how the extra space separation between the letters makes the spacing between all three letters similar. We can see how the space inside the letters (marked in light blue) is similar to the space between them, even if it is made up of different forms.

To the right is an example of letters with a similar structure but with a much greater weight. Notice how this affects the space within and in between the letters.

★ This general rule must always be kept in mind: the space between letters must be the same as that within the letters, and the spacing between words should be the equivalent of the width of the letter *n*.

Do not forget that this is a general rule that we can apply with greater or lesser importance depending on our project. For example, if we are going to work at a very large size, generally the space will be somewhat tighter than in smaller dimensions, where you might even have to leave some more white space in between letters. On the other hand, the structure of capital letters allows a generous spacing, while in the case of minuscules we should apply this rule in a more rigid way.

It is also important to consider the space between words when dealing with texts. Generally speaking, there should be enough white space for the reader to notice a separation between two words, but not so separated as to negatively affect the pace of reading. As a standard, the space we must leave between words should be the same as the space occupied by the letter *n* of the style with which we are working.

Uniform thickness. We have been talking about where thick and thin elements should be in letterforms, but I have not stressed enough the importance of these weights remaining uniform throughout our lettering work. Even if the stroke is modulated, we will always have a maximum thickness and a minimum one. These thick and thin values should be constant across a set of letters, with the stem of a letter *n* having the same thickness as that of an *i* or the maximum ring width of an *o*. The same applies to thin elements. We have to ensure that the serifs and the connections between different parts of the letter always have the same thicknesses.

In addition to contrast, we must also control the modulations of the strokes. That is, if in one letter we have an abrupt contrast, it does not make sense that in another the contrast is more modulated.

▼ In the *hon* on the left, we can see that although the letters have a similar appearance to the one on the right, certain elements, such as the thickness of the stems, serifs and modulations, are technically quite inconsistent. On the other hand, in the second example, I have paid more attention to these elements, resulting in a much more homogeneous appearance.

hon hon

RHYTHM, SPACING AND FORM

Formal resonance. As we saw a few pages back when creating schematic letters, there are certain formal relationships between the different letters of the alphabet that give the alphabet consistency. Some of these relations are more obvious, such as the similarity between *n* and *m*, while others are somewhat less so, such as the relationship between *o, c* and *e*. There are also other letters that do not resemble each other on a superficial level, such as *a* and *v*. We call this relationship between letterforms *formal resonance*.

When it comes to planning our work, we must be consistent with these relationships, since they are the ones that will make our letters "resemble" each other. You should avoid, for example, mixing rounded and angular shapes, or terminals of different shapes, as this will make a set of letters less coherent. The more similar the shapes are to each other, the more consistent our set of letters will be.

▼ When examining the letters of the *ana* on the left, notice how they work individually but not so much as a whole, since rounded forms are mixed with angular ones, resulting in an inconsistent overall appearance. On the other hand, the example on the right is more homogeneous, with a consistent level of tension in all of its forms, contributing to a better overall appearance.

I will conclude this section by insisting that when carrying out a lettering project, the most important thing is to make conscious decisions about the form the letter will take. And above all, to remember to apply those formal decisions throughout the project. A set of letters in which there is no consistent formal criteria will simply not work.

OPTICAL ADJUSTMENTS

Having applied all the principles we have seen so far, you should be able to draw some pretty good-looking words by now. We have discussed the basic structure of the letter, how to "dress" it, techniques for drawing, and what to look for when giving a word its rhythm. But if we want to achieve an impeccable finish, we must be aware that there are some optical adjustments and refinements that we need to apply to our letters to make them balanced.

In order to achieve this, the first thing you should know is that in lettering there is no such thing as geometry, and mathematics is of very little use to us. In the same way that spacing is something we can only measure optically, letterforms cannot be built from pure shapes as they would look unbalanced and static. Type designers apply hundreds of small adjustments to make alphabets attain a consistent rhythm. But before starting with some exercises, I will first explain four rules.

▼ Notice how the geometric shapes on the left, despite being the same height, look uneven, while the shapes on the right appear to be the same size.

Overshooting. Let's refer back to our geometric figures. A square, a circle, and a triangle will look uneven even if they have exactly the same height. The circle, and above all the triangle, will look smaller than the square, as they are surrounded by more white space. To avoid this, we make these shapes protrude slightly from the guides that delineate the shapes' height. When applying this principle to our letters, those with curved or triangular shapes should be larger than those set between the baseline and the top-most line (ascender line, cap line or x-height). This principle is called *overshooting*.

▼ All letters in the illustration below have been adjusted. Notice how features such as curves or apexes exceed the guide lines.

Horizontal symmetry. Among the forms of the alphabet, especially in capital letters, there are a series of letters whose structure is horizontally symmetrical, meaning that if we divide them by the centre, the top part will be the same as the bottom. A good example is the letter *H*. When we look at a mathematically perfect drawing of an *H*, with its bar centred in the middle, it will look as if it is slightly displaced downwards. The way to solve this will be to move it a little bit upwards, leaving its bottom white space a bit larger than the top. This way, the reader will see a perfectly balanced shape. We also apply this adjustment to *B, E, H, S, X* and *Z*, and to some of these letters in their lowercase form. Notice how I have already been applying this adjustment in other schematic models throughout the previous pages.

▼ The bar of the first H is placed right in the middle of its height, which causes a somewhat strange optical effect. This is corrected in the second H by placing the bar slightly higher than the middle. In B and X we see similar corrections.

Horizontal and vertical thicknesses. In accordance with Gerrit Noordzij's theories (see page 36), we have seen that the thickness changes depending on whether the strokes are horizontal or vertical. There are times when we might want to work without contrast (this would be called *monolinear stroke*) by having all stems and bars with the same thickness, regardless of their orientation. Even so, we must be aware of an optical effect: even if they are of a similar thickness, a horizontal bar will always look thicker than a vertical stem. We must correct this effect by making the horizontal stems slightly thinner. This is yet another example of how perfect geometry does not always work.

▼ Once more, the letters E T on the left are poorly constructed. In this case, the horizontal bars have the same thickness as the vertical stems. If we look at the E T on the right, we see how the adjustment in the thicknesses of the bars makes the letters look more balanced.

▼ Although they are not straight shapes, the letters below use the same type of adjustment as in the previous example. Notice how in the O D on the right, the most horizontal parts of the curve are slightly thinner than the rest.

This does not only affect straight lines but also curves. Letters such as *O* or *D* follow a path that runs both horizontally and vertically. In these cases, the parts of the curve that run horizontally – i.e. the highest and lowest points of each letter – will be somewhat thinner.

Connections and joints. In the majority of letters we find different parts of the letter that are connected to each other, such as the shoulder of the *n* with the main stem, or the apex of the *A* where the two stems meet. In these cases, if we are working with a low contrast and do not make any correction, it is easy for us to produce a visual weight in the link that needs to be adjusted. In the case of a straight stem that connects to a curved stroke, as with the *n*, the latter must be thinner as it approaches the former. When two diagonal bars are joined together, as in a *v* or at the apex of an *A*, they should be refined at the point just before they meet.

▶ Another "bad vs good" example. The first letters are purposely misconstructed: connections between different parts of the letter make the letters look stiff and blocky. In the second set of letters, a few slight adjustments in the connections result in the shapes working much better.

In short, the one idea we must be clear on is that for our letters to look perfect, the drawing must be, to a certain extent, "imperfect". This is another way of saying that geometrically pure forms do not exist, or if they do, then they are not going to look pure but deformed. If you observe geometric typography such as Futura on your computer screen, you will see how it is full of such small modifications. The four rules above are, let's say, an introduction to optical adjustments, since each letter and each style will have very specific issues to solve. But for now, familiarity with these four rules is already more than enough.

▶ EXERCISE

Let's try a slightly more challenging exercise now. Select a letter style of your choice and use it to draw a word between 6 and 8 letters long that includes both round (o, c, e) and triangular shapes (v, w, A...). It is up to you to decide whether to use upper or lowercase letters. Either way, use the following process:

• Make a series of small sketches until you settle on a style you like. Keep in mind that it has to be relatively standard. Don't worry too much about the details, but think about the overall rhythm of the word. Once you have decided, magnify it to about 20 cm wide using a photocopier.

• On parchment paper, redraw the letters, paying special attention to the drawing techniques we have discussed, and importantly, to the concept of drawing the letters in parts! When you are happy with the forms, shade in the letters.

• Refine your drawing on a new piece of paper, adjusting the spacing and thickness, and making sure that the shapes work as a coherent whole.

• Check your drawing once more, and if needed, apply the relevant optical adjustments. Redraw as many times as you see fit, until you are satisfied with your word.

• Finally, ink in your drawing, paying a lot of attention to detail and technique. If you followed the steps well, the resulting letters should look IMPECCABLE!

▲ I have done several tests for the word AVIONES (Spanish for aeroplanes). I started with an Italic structure with a high contrast and a moderate inclination. I then slowly transformed this initial proposal into a more geometric one, which you can see at the bottom. The purer shapes and increased thickness uniformity should make adding optical adjustments easier and the result more evident.

BASIC PRINCIPLES

▲ Let's look at the evolution of the finished word. In the first drawing, I redrew an enlarged version of the first sketch and made some corrections intuitively. Here I point out some small spacing and weight errors. In the second step, having corrected these errors, I indicate some optical adjustments that must be done, and which we see already applied in the third step. Finally, we can see the final result, which is practically the same as the previous version but contains some slight weight adjustments.

DIFFERENT APPROACHES

It is safe to say that by now, you should have a fantastic understanding of how to construct letters and words. Even this level of knowledge (maybe with a little hard work and patience added in) should be enough to set you on the path to lettering stardom – congratulations! Still, the exercises we have completed so far might have left you hungry for some lettering that is a bit less formal and a bit more exciting. It is great if you feel this way, but remember that to do more complex and expressive work, we must first have a good command of the basics. We must learn to walk before we can run.

Maybe this is a good time to open an aside in this narrative to tell you about what I see happening in social networks, where many people interested in lettering try to kickstart their career as letterists by running right from the start. This rush inevitably leads many of them to commit almost criminal errors that are capable of keeping even the most cold-blooded person awake at night. Even worse is their capacity to attain a considerable number of likes for these mistakes. This is why I cannot overemphasise the importance of knowing the basics well enough. Only once you have confidence in what you are doing do I recommend setting yourself higher and more complicated goals. Let's all try to be better professionals.

In the following pages, I am going to show you a range of personal work, aross which you can see several different strategies or approaches to a lettering project. The intention is to present you with a series of work, from a simpler and more formal, almost typographical approach, to others that are more complex and expressive. This is not meant to be a catalogue of possibilities or some kind of recipe book, but just a collection of different case studies that should help you understand how far and how different a project can evolve depending on the approach taken. Nor is it meant to show that some solutions are better or worse, but rather that the resources and approach we use on a project also depend on what the commission or brief requires.

BASIC PRINCIPLES

Poemes per a una Verge

▶ This style of calligraphy – which is based on minuscule Carolingian (even if in this case it is heavy on serifs) and has its origins in the 15th century – is called humanist. Letters that have similar characteristics are classified under the same name.

Poemes per a una Verge. This lettering was done for the cover of a deluxe edition of a compilation of poems dedicated to the Virgin of Montserrat. The commission required a classical and formal approach, but at the same time sought a certain warmth. The lettering style is a very formal and controlled humanist-type calligraphy. It could almost be a typeface, were it not for the imperfect finish and the decorative character of the letters, such as the capitals or the descenders.
Note that in terms of composition, it does not have a perfect central axis; but it still achieves a sense of balance, even if the guides move from one side to the other. We call this a *centred balanced composition*.

DIFFERENT APPROACHES

LITTLE WILLIE JOHN

◀ This style of lettering, specifically how the letters interact, is called *Interlock*. It is very characteristic of the 1960s, when it was used in a variety of contexts, from sweet wrappers to horror movie posters.

Little Willie John. I drew this composition for the cover of a rhythm'n'blues album. To evoke the musicality and rhythm of the content, I thought of using a rather neutral lettering style. You can see that the letters are sans-serif and have low contrast, but have a very accentuated dynamism derived from the letters' irregular height and the interaction between them, as in the word LITTLE or the two Ls of WILLIE. The finish is also irregular. Far from being a clean line, the fill-in is rough, and you can even see some broken streaks within the stems. Once again, I have used a centred balanced composition.

▶ Lettering styles or typefaces that, as in this case, have a calligraphic root but whose forms are clearly drawn (and have thus lost a certain calligraphic element) are called scripts. Almost all the features described on pages 34–35 can also be applied to scripts.

El Bandarra. Logotype for a vermouth. Notice how the approach here is very different from the previous examples. Instead of starting from a composition similar to how we would create a typeface, the logotype starts off as a handwritten cursive word, with letters linked together as if it was written in a single stroke. But this is only the starting point, as the form was digitally reinterpreted with a vector drawing program in order to get the cleanest finish possible and to have better control of the letterform. As the logotype is printed in sizes ranging from a small bottle cap to the side of a truck, the overall shape has to be more considerate of where it will be applied than, say, lettering for a book cover. The challenge here is to maintain the same dynamism and rhythm as that of hand-drawn lettering.

DIFFERENT APPROACHES 57

◀ Psychedelic lettering is not exactly known for its legibility, but there are occasions when we can allow the balance between expression and legibility to be tilted towards the former, as is the case here. The opposite extreme would be, for example, to design a typeface for motorways, which would clearly need to be as legible as possible.

The Zephyr Bones. This is the design for a T-shirt for a group of the same name. The idea was to reference the lettering of the classic psychedelic posters of the late 1960s. In this case, there are two things we can observe. On the one hand, we have letterforms that have been heavily distorted so that they can fit into a set structure, turning the letters into a sort of pattern. This is achieved by opening nearly all internal counters with similar shapes (an example of formal resonance). It is interesting to see how the basic structure of the letters has been sacrificed to allow for greater expression. On the other hand, the words are also adapted to a particular shape to emphasise the idea of distortion that evokes the band's musical style.

▶ Instead of giving the geometric letters a neutral and synthetic finish (like the style of the letterforms), in this case a decision was taken to contrast these qualities with a simulation of a metallic effect (after all, the word oro means GOLD). These juxtapositions can be made to play in our favour, bringing a certain conceptual richness to our work.

Oro Negro (Black Gold). Lettering for the front page of a book about the Spanish musician Tino Casal. The brief required a look and feel influenced by the 1980s, hence the layering of geometric shapes rendered in a metallic effect complemented by loose calligraphy. Using very basic letter structures, the word ORO (GOLD) pushes the limits of legibility, but despite this, the forms are still recognizable. Another characteristic of this lettering is the contrast between the two-letter styles: one is stiff and geometric while the other is highly expressive and takes advantage not only of the gesture of the writing but also the texture of the brush. Later on we will be talking about how to mix letter styles successfully.

DIFFERENT APPROACHES **59**

◀ In this example, instead of scanning the label to work with it on the computer, I photographed it and then edited it in an image retouching program. This gives me an even more expressive finish, as the camera distorts the composition and also adds a layer of photographic grain that gives the letters a slightly unfocused feel.

Who Can Kill a Child? This is a personal project in which I reinterpret the poster of a horror film that goes by this name. It is a story which is told in a very raw manner, so I wanted to draw a title that reminded one of a certain cruelty. Using a condensed classical uppercase letter style as a starting point, I distorted its height and composition and emphasized the serifs and apexes, turning them into very sharp and heavy elements that feel violent. In terms of composition, notice how I give more importance to the two keywords of the movie title: MATAR (kill) and NIÑO (child). The irregular finish, which was achieved using a thick marker, adds a level of drama to the composition.

▶ In this composition, the decoration is of vital importance. Although ornaments and letterforms are different elements, there are concepts (rhythm, space, mass, etc.) that are equally valid in ornamentation. It is also interesting to mention that in no case should the decoration that we place around the letters take on more importance than the letters themselves.

The Story of a Country Town. Here is another cover for a novel, this time requiring a whiff of Victorian air. To do this, I composed lettering using mostly capital letters with a simple structure but with some serifs and decorative elements that add a charmingly antique veneer. For the main word of the composition, COUNTRY, I have used a different inclination as the rest of the words, made it larger and decorated it more. Moreover, elements such as *of a* and the author's name use different letter styles, which add an added layer of personality. As finishing touches – to aid the composition and give it a more contemporary look – I have included some Victorian decorative motifs. In conclusion, you have to be aware that for a relatively complex composition like this to work, all the elements have to be balanced.

COMPOSITION

Finally, it is time to see how we can compose a complex lettering project, using a combination of different words, formats and letter styles. This will be the last theoretical chapter, the end of a course that started by learning how to draw a letter according to its structure. Later, we refined its outline and shape, followed by a section in which you learned how to compose a set of letters to form a word that makes sense. We have just been through some examples of real case studies in which we have seen different ways of approaching a lettering project. In this last phase of the section, we will be speaking about composition.

When we talk about composition in its greater sense, we are actually referring to three separate actions: organizing information, combining different styles of letters and defining the form of our lettering.

Establish a hierarchy. When planning a project in which there is a text composed of several words, we likely want to give more importance or presence to some words over others. This is how we establish hierarchy in our message.

Hierarchy is usually established based on the content of a text. This means that within the phrase on which we are working, there will be some keywords which we would be interested in highlighting because of what they mean. For example, if you look at the lettering on the opposite page, you will see how in this case I have highlighted the word COUNTRY because I thought it said something specific about the book that the other words did not. The final cover design was even accompanied by a rustic, country-themed illustration. We can say that in this case, there are three levels of communication in the title. The second level would be the words THE STORY and TOWN, while the third would be the two monosyllables OF A and the author's name (I am sure we agree that, despite having different letter styles, they are at the same level of importance). Complex compositions such as this are not easy to pull off. One needs to be wary of certain pitfalls, such as unnecessarily complicating a composition by adding an infinite number of letterform styles and reading levels, as this is an approach that usually results in a chaotic rather than a functional solution.

Establishing what information to highlight is not always easy, since the criteria for doing so can be subjective, and it also depends on the context in which we are going to be using our bit of text. For example, let's think of different ways in which we can design the cover of this book using just letters. We have the following information: the title, *Lettering to the Max,* and the author's name. Let's imagine three scenarios. In the

first one, we are going to give prominence to the word Lettering. This makes sense, given that this is a book about this subject, and we also want to make it easy for potential readers to spot the book at a book store, by merely looking at the title and relating it with their interest in learning how to draw letters. This criterion seems to be the most logical and realistic, and in fact, it is the one we applied on the cover of the book that you currently have in your hands.

Let's imagine two parallel dimensions. In one, I am a successful and world-renowned author with a few bestsellers behind me and millions of followers eagerly awaiting my new book launch with banknotes in their hands. This is not the case, but if it were so, the design of this book's cover would feature the author's name ahead of anything else. It would not matter if I wrote a guide to making letters using lace or breadcrumbs, because the main element of the cover would still feature my name in large, golden letters. In the other dimension, imagine that this book is part of a series that the publisher directs to highly motivated people, a sort of extreme self-help series. In this case, TO THE MAX would be ahead of the author's name, and also ahead of the main subject that the book deals with. It does not matter if it is lettering, confectionery or knitting, because all they want is to go TO THE MAX.

If we are working on a professional commission, our client (in this case, the editor) will probably highlight this hierarchy themselves. When working on a more personal job, we must establish a logical criterion before making decisions regarding the hierarchy of our project.

▼ Here are some very quick sketches of the composition for the three hypothetical covers I mention in the text. As you can see, despite containing the same information, the message changes completely depending on which element we give more importance to.

The hierarchy does not only serve to communicate the parts of a text that are more important. By differentiating the different elements of the composition at a size level, we are also giving it more rhythm and visual richness: making it visually more interesting for the reader of our message, and also aiding legibility. Using this book again as an example, even these very pages have different levels of reading. We have titles at the beginning of each chapter; the body of text you are reading right now; secondary titles in bold at the start of paragraphs that introduce new content; captions; headers… each text is treated differently according to its function. Just imagine if everything was treated in the same way: it would undoubtedly be more difficult to read, not to mention extremely boring. It is hierarchy that marks the difference between one situation or the other.

Combine different letter styles. One of the strategies for establishing different levels of reading, or simply to give a different feel to the different words in a text, is to use several letter styles. When dealing with complex word compositions, it might be tempting to go ahead and use a lot of different styles, yet this can quickly get out of hand if we don't do it with a certain restraint. Let's go over some tips for combining letter styles successfully.

The first thing to keep in mind is to avoid working with too many styles at the same time, because on the one hand this can be difficult to control, and on the other hand it may not even be necessary. When deciding on a letter style, keep in mind that there are many ways in which a letter can manifest itself, even within the confines of its style, meaning that two stylistically similar letter styles might actually be enough. While keeping the same letter structure, think of the possibilities that a simple change in size, weight, proportion, etc., gives you. This way, the combination of different variations of a similar style will lead to a more coherent final result.

This does not mean that it is impossible to be in control if we work with a couple of letter styles and all the variations we can derive from them. Having two letter styles that complement each other will give our composition a certain tension that makes it visually more interesting and positively complex. When it comes to combining two different typefaces, what we want is for them to complement each other well, yet this does not always happen.

▲ Two examples of letter style combinations. By this point you should easily be able to tell which one works and which one does not.

The main criteria we should look out for when dealing with two styles of lettering is that there must be a certain level of contrast between them. This means that they should be different enough to generate a certain visual tension. Styles which, despite being different, have elements in common, cause a certain visual discomfort on the eye, and our composition will feel strange. So, the more tools we have to make our styles contrast, the better: size, weight, proportion and above all, structure.

Let's take an example. In the illustration above, you can see two different letter combinations for the words *Buenas Noches* (Goodnight in Spanish). In both cases, *Noches* is drawn in a script style, with a visible calligraphic influence, and is the main element of the composition. In the first case, the secondary style I have chosen for *Buenas* is the fantastic humanist Italic typeface Adobe Garamond Pro Italic, which although not hand-written, has a clear continuous structure and a reduced contrast that is typical of flat-nibbed pens. In other words, its structure is very similar to that of *Noches*.

Moreover, the size of the two words is fairly similar, as are the contrast and weight. Basically, I have used two letter styles that are way too similar to produce any contrast, and because they are not exactly the same, this causes a certain visual discomfort. On the other hand, the second example shows *Buenas* using Akzidenz Grotesk Light: a fairly fine sans-serif that lacks contrast and has a much wider proportion than *Noches*. To further differentiate it from the minuscule *Noches*, *Buenas* is written in capitals. As you can see, in this second case the combination of styles is much more effective, as the words contrast well with each other at all levels.

Even if this example illustrates the search for balance when contrasting letter styles, there might be instances that call for something a bit more exaggerated, stylistically speaking. In which case the liberal use of different letter styles is understandable, as long as there is some underlying balance between the letters that establishes a hierarchy.

COMPOSITION

Define the form. Here we are referring to the form of the composition itself, or how we place different elements within a format and in relation to each other, so that the final form is logical and effective. Composition is a complex subject, and I could easily write an entire book about it. Deciding what does or does not make a good composition is also fairly subjective, making it impossible to define by a set of universal standards. In any case, let's go over some basic principles and some common problems that you might come across when starting on a lettering project.

One thing I should make clear is that you should always start from a simple formula. Note that I say "start from", which means that although our finished work might take on a complex nature, we must begin it with a simple structure, in the very same way that we did back when we started drawing letters. In order to achieve this, the most important thing is to have the compositional axis clear right from the beginning, as this will determine the visual direction that all the compositional elements will follow. For example, if we work with a very condensed letter style, with words arranged in a column and using a very narrow format, the axis will be clearly vertical.

On the other hand, if we place a sentence composed of a single line in a landscape format, the tension will be horizontal. These are very obvious examples, but it does not always have to be this way. Let's look again at the example on page 60, *The Story of a Country Town*. What would the axis be here? Well, the word *COUNTRY* indicates a distinct diagonal axis, but in reality there is a secondary horizontal axis, indicated by the rest of the words. Therefore, we have a main diagonal axis and a secondary horizontal axis. The composition was then concluded with the addition of ornamentation, but it is important to remember that everything started from a diagonal line.

▼ Here we can see the compositional evolution of *The Story of a Country Town*. In the first step, COUNTRY defines the main visual axis. In the second step, the rest of the text defines a secondary axis. Finally, the addition of ornaments concludes the composition, perfectly accompanying it with a decorative complexity.

Speaking of which, a diagonal can have two directions: ascending, i.e. from the bottom left to the top right, and descending, which is the opposite. When looking at an image, the eye tends to start reading from the upper left corner of the format and ends up in the opposite corner. Compositions that follow this system tend to look obvious and too easy to read: our eye will find them uninteresting. We must, therefore, avoid using the descending diagonal.

When working on a complex composition, it is vitally important to take space into account, just as we do when we are dealing with a simple word. It is not only necessary to control the white space between the letters, but also between words, lines and the relation of the mass to the format with which we are working.

The idea here is for the space to be always homogeneous, so that our composition looks as uniform as possible. Below this paragraph, you can see a simple composition made of three blocks, which could be words, blocks of text or images – it does not matter. In the image on the left, there are several problems. One is that the space between the two top blocks is larger than the space between the top and bottom set of blocks, and this generates an irregular tension. In the middle image, this problem is resolved, since the distance between the different blocks is similar, both horizontally and vertically. But we still have a problem in that there is more space in between the blocks than around them. The fact that the blocks are closer to the edge of the page than to each other makes the composition look scattered and unfocused. Finally, in the example on the right, the white between the blocks is less than the space around them, leading to a compact-looking unit that is formed around the centre of the composition.

▼ Here, the relationship between the different blocks of the composition is similar; however, you can see that small differences and the relationship of the whole with the format is important. The first composition is very unstable, while the last one is correct.

Another factor which has a big effect on the visual outcome is the placement of the composition on the format. Here we have two options: to look for a natural and comfortable composition or to try to come up with something which feels more risky and irregular.

In a natural composition, we would place the mass in the optical centre of the format. Note that this does not translate to the *geometric* centre. You might remember the part in the chapter on optical adjustments when you learned how to balance symmetrical letters, achieved by leaving more space at the bottom. Back then we had seen how the bar of an *H* had to be moved slightly upwards for this to happen. Well, something similar happens here. If we place our text block in the exact centre of the format, the composition will have no energy, and the mass will look weak. But if we move it upwards until we achieve a space distribution of approximately 60% below and 40% above, the result will be much more stable and will feel more dignified.

If what we want is to generate visual tension, then what we need to do is the opposite, by focusing the elements around a point other than the centre. For example, we can make everything aligned to the left or right, or place all the weight of our shapes at the bottom of the composition, or in a corner. All these proposals can be valid if we carry them out in a determined and calculated way that reflects the intention we have in mind. Such compositions need to be assertive, as stopping half-way would make them feel half-baked and they would not have the necessary strength to be pulled off successfully.

▲ In the first option, although the space between the elements is uniform and they are surrounded by sufficient white space, the composition feels flat and lacks tension, since the space above and below the shape mass is exactly the same. In the second option, I have raised the mass in order to improve the composition. In the last option, the composition is much more intentional and dramatic. We can use one or the other, depending on the effect we would like to achieve.

BASIC PRINCIPLES

▶ **EXERCISE**

In this exercise we are going to work with composition. Think of a sentence that is long enough for playing around with, but which does not have too many words, which would make it too hard. Something between 5 and 10 words is perfect.

• Establish a hierarchy. Remember that the meaning of the sentence will vary depending on which words you choose to emphasise.

• Think about which letter styles you are going to use. Remember that they must contrast well with each other, in terms of style, mass and size.

• Make composition sketches, defining a horizontal, vertical, inclined, or combined visual axis. In this part of the process, remember to sketch at a small size, as this helps you visualize the composition without wasting too much time on detail. Try several different solutions!

• Once you have a composition that works well, finish your work by blowing it up and redrawing it using parchment paper, as we did in the previous exercise.

▲ Here is a selection of sketches I have done for this job. The sketch at the very top shows the sentence, still formless, yet in the process of establishing a hierarchy. This is followed by some simple sketches that establish the composition, and which are later adapted to show alternative solutions for letter styles, distribution and axes. The sketch beneath this text box is the last pencil sketch, just before it was inked up.

▲ For this "ironic" phrase, I tried to get across something akin to a hipster aesthetic, a kind of contemporary revival of Victorian aesthetics. I have mixed a monolinear script of moderate thickness with a condensed capital letter that lacks serif or contrast, yet which visibly has more mass. The decoration is quite overloaded, but by rendering it in a very fine line it avoids competing with the letters. Observe the use of the different visual axes and the balance between the different elements. There is text above and below the main word (for this I have taken grammatical licence, as the correct phrase would actually be *Hipsters please use back door*). The decoration is also evenly distributed throughout the composition; this serves not only to decorate but also to make the image more compact.

NOTE: This illustration was made without any intended bitterness towards hipster culture. I myself have many hipster friends and with some of them I actually get on reasonably well. No offence meant!

Different Styles

It should be clear to you by now that the world of writing styles is pretty vast. Multiple variables, each of which can change the outcome of a letter, lead to an extensive number of possibilities, and when we are starting out, this can leave us scratching our heads.

But before we jump in, let me just add that it is normal for anyone to have trouble getting used to the idea of dealing with different letter styles. In this section, I will be showing you three basic alphabets and some variations, using them as the basis for learning how to add expressiveness to letters.

As I said earlier, even though this book is really about lettering, we will also be practising a bit of calligraphy. Applying the round brush technique to write Italics should really help you understand how to use continuous structure systems and also the logic behind thick and thin. We will also be learning how to achieve more expressive letterforms and freer word compositions. Besides, after working through the whole book so far in such a technical manner, I am sure that you will appreciate a slightly more relaxed approach to letters and letter making.

SANS-SERIF

These models are idealised sets of letters from which we can derive more personalised forms. The idea is not for you to copy them as they are, but to use them as a reference when designing your own letters and to consult these sets when you have doubts about letter shapes or the criteria that should be applied.

Here you can see an example of a set of sans-serif letters. Sans-serif is also sometimes referred to as *grotesque*. As you can see, its main characteristic is the absence of serifs in the terminals. Popular typefaces that fall under this classification are Gill Sans, Helvetica and Franklin Gothic.

Another very obvious feature is the low contrast, which in this case is the minimum allowed in terms of optical adjustments. Usually, a sans-serif typeface has a very low contrast, although it does not always have to stick to this standard. Optima, for example, is a sans-serif typeface with a very accentuated contrast.

These particular models are based on the basic structures shown on pages 29 and 31, but as you can see, a medium thickness has been applied here. But, remember that this is just an example: you can alter the shapes and proportions if your project requires you to do so.

abcde
fghijk
lmnop
qrstu
vwxyz

SANS-SERIF

ABCDEF
GHIJKL
MNOPQ
RSTUV
WXYZ

▶ On pages 34 and 35 we saw a series of variable factors that all affect the final form of the letter. Let's see how these factors affect the shape of sans-serif letters. This should come in handy when you are making your own variations. From top to bottom:

• **Shape**. As you can see, the bowl of the first P is very geometric and rounded, while the last one is more squarish, having a superellipse shape (or *squircle*). The one in the middle is the most conventionally shaped, but they are all correct.

• **Proportion.** The width of the structure of a letter can also be variable.

• **Weight.** The same applies to the weight or thickness of a letter. As you can see, in this case the three Rs have the same structure, but each one has a dramatically different weight.

• **Contrast.** Usually, sans-serif letters have very low contrast, although this is less of a rule and more of a standard. The A on the left is monolinear, the one in the middle has a slight contrast, while the last one is highly contrasted.

• **Terminals.** Amateur letterists often overlook this concept, but the terminals of a letter can have a decisive influence over its final shape and rhythm, so pay special attention to how you finish your letters.

▶ EXERCISE

To test your understanding of sans-serif letter structure and your creativity in generating letter styles by varying factors, try the following exercise:

Draw as many variables as you can imagine, thinking of different letter styles that may accompany a text. In other words, try to think of words that you can associate with certain letter styles. Here are some examples to help get you going. *New York* is drawn in an Art Deco-inspired geometric style, reminiscent of the signs on Manhattan skyscrapers. For *Comedy*, I used a playful lettering style, which is fairly narrow and in which the baseline is very irregular, as is the height of the letters. *Hawaii* has a style that we can associate with surfing and the '60s, not only because of its structure but also the irregularity of the thickness of the stems, which end with a sort of serif at their terminals. Basically, all I did here was draw words in a style that was representative of what the word means.

As you can see, the different proposals are very varied. We can play with upper and lower case, proportions, weight, terminals, composition, and so on. The main idea to understand here is that we can generate a multitude of letter styles simply by departing from the basic examples on the previous pages.

I left these examples as pencil sketches because I was only interested in generating a variety of styles, but do feel free to finish them off in ink if you like!

SERIFS

In this model we have a set of letters with serifs, and with a fairly accentuated contrast. The characteristics of these letters qualify them as Roman. Yes, I am aware that structures derived from the Carolingian are also called Roman and the confusion that this may create, but we can avoid this simply by referring to letters such as the ones on this page as "serifs". Garamond, Caslon and Bodoni are all classic examples of common Roman typefaces.

This example will come in especially useful when deciding where to place serifs and where to place the thick and thin parts of a letter whenever you are dealing with a project that requires contrast. The theories of Noordzij should have made this last aspect clear, but it does not hurt to have an example to which you can refer when in doubt.

Once again here, the structure of these letters corresponds to the schematic examples with which we worked at the start of this book. If you compare the letters on this page with the sans-serif ones from four pages back, you will notice how the structure is essentially the same, despite the two of them having totally different characteristics.

Serif typefaces tend to be associated with an increased contrast, but there are exceptions, as we can see in typefaces such as Rockwell or Clarendon.

a b c d e
f g h i j k
l m n o p
q r s t u
v w x y z

SERIFS

ABCDEF
GHIJKL
MNOPQ
RSTUV
WXYZ

▶ Let's have a look at how contrast in serif letters can be modified by means of different variables. From top to bottom:

· **Proportion**. Here we have an evolution of an R, starting with a condensed or narrow version and ending with an extended or wide one.

· **Weight**. Once again, we have three examples of three different weights applied to the same structure, starting with a thin S and ending with a heavy or black S.

· **Contrast**. Contrast in Roman typefaces can vary. In the first example we can see how the contrast is very low – something rare, but possible, in serif styles. The central D has a moderate contrast while the last one is very contrasted. Notice how the thickness of fine strokes ends up affecting the thickness of the serifs.

· **Serifs**. As we have just seen, the shape of serifs is related to contrast and weight. Letters with a gentle finish, as in the first example on the right, have moderate contrast, while a contrasted style would have very fine serifs, as in the second example. Letters which have serif styles other than these two are usually more playful and decorative in nature, as we can see in the examples on the bottom line.

► **EXERCISE**

This exercise is essentially the same as the one you did on page 75, but this time using serif letters. Think of a series of words or short phrases and draw them in a style that brings out their message or meaning.

To explain some of the examples I have drawn on this page, have a look at *Serif*, which is drawn in a Western style. Serif/Sheriff – get it? Maybe not the best joke, but you can see where I am going with it! SPQR is made using classic Roman letters while *The Exorcist* is drawn in a spiky and rough style that brings to mind horror movies. On the other hand, *Carmen Sevilla* (a famous Spanish actress) is rendered in a style that evokes the Spanish comedies of the 1960s.

The majority of the examples reference retro-pop styles, and for me, they did not require that much thought to come up with. Try to find concepts that you like working with and think of shapes and forms that you can easily draw.

BRUSH CALLIGRAPHY

We will now approach letterforms from another point of view. So far, we have seen how to shape the outline of a letter by starting with the structure first and always through using drawing techniques.

As you saw on page 36, the majority of the shapes of letters have a calligraphic origin. Up to now we have been working with letter styles whose stylistic base is in some way closer to the more static forms of typography. Projects of this type should be easy to carry out successfully if we have a good understanding of the different variable factors that can affect letterforms (weight, contrast, axis, proportion, etc.). However, if the focus of our work has to do with solutions that are related more to writing, such as the script styles on page 56, a lack of practical knowledge of calligraphy can be a problem.

We can do calligraphy using a variety of techniques, but there are essentially two types of tool that are used: flat-nib and expansion. Even if, when we talk about scripts, we are mainly referring to the continuous structure, the letter shapes that we probably have in mind are those that are produced using an expansion tool, and more specifically, the round brush. Nowadays, brush-based calligraphy is perhaps the most popular of all styles, or at least that is the feeling we get when we take a look at social networks. This is not surprising since it is a very versatile technique with which we can achieve very varied results, and which is very appropriate for expressive calligraphic styles.

In this chapter I will explain the basics of formal writing with a round brush. The intention is not so much to go into technical depth or to investigate the expressive possibilities of the tool, but rather to make you understand the dynamics of continuous line writing, as well as the logic behind thick and thin strokes when using an expansion tool. Later on, this will come in handy when you are faced with a script-style lettering project, especially those of a more "formal" nature. So, let's get to work with the brush. The letter structure we will be using is similar to the one that uses small Italics on page 30.

When you take your first steps with a brush, the first thing you should understand is the relationship between the thickness of the line and the pressure we exert on the tool. The basic theory is easy: the more you press, the thicker the line. The first difficulty we will encounter is getting used to the touch of a particular tool. A brush is a very sensitive tool, and any small variation in pressure can make our line look too thick, too thin or too irregular. If the brush we have chosen is a fine hair-based brush, then it will be more sensitive than a fibre-based

BRUSH CALLIGRAPHY

brush (i.e. a brush with a flexible marker tip). This is a good thing, as it allows for a wider range of thicknesses and a warmer texture. But on the other hand, a fibre brush is easier to control. It is up to you to decide which tool to use. The second difficulty will come when we have to decide when to press and when not to – that is, when to use thick lines and when to use thin lines.

Let's start with an exercise that will help you understand these two basic concepts: how much and where we have to press. The first thing will be to draw some lines or a grid that will help you control the height of your strokes. On a sheet of A4 paper placed in a landscape format, and using a black marker, draw parallel and horizontal lines at a distance of 15 mm from each other. This pattern should be placed underneath a transparent sheet of paper on which you will be practising, thus allowing you to see the lines or grid without drawing on them. Ideally, you should use laid paper of around 90 gsm, since it works better than normal paper when working with ink.

When it comes to practising letters, you should, first of all, have the brush in the correct position. Hold the brush at an angle, and point it in a direction perpendicular to the direction of the stroke, as this will allow you to better control the thickness of the stroke and the shape of the terminals. Therefore, as we are going to do a slightly inclined type of writing, the brush should come in from the "southeast", so to speak, meaning that the tip of the handle should point towards the elbow and not horizontally from the right.

▲ Observe the correct position for writing with the brush: tilt it a little and hold it in a position that points slightly downwards to the right, not completely horizontally.

▼ It is important to be able to see the underlying grid well when practising. To do this, the paper on which you practice should not be too thick, and the lines of the grid should not be too thin.

> ★ "If I am left-handed, can I do calligraphy?" Yes, of course! Simply keep in mind that you must hold the brush at the same angle. So, instead of coming in from the "southeast" you should attack from the "northwest". This way the angle of the brush will be the same – notice how the terminals end up having the same inclination. Be careful not to smear the ink with your hand, although if you work with a suitable paper, you should have no problem with this.

Having understood how to hold the brush and with your papers and gridlines ready, it is time to start the first exercise. The first thing you will do is write slightly inclined strokes, starting from top to bottom. The thickness of the strokes should be approximately 3 mm. It is crucial to maintain this thickness along the entire line, to ensure that all the lines have the same weight. Moreover, if the brush has been held correctly, then you will probably see that the ends of the strokes have a slightly oblique shape.

As soon as you have control over the thick strokes, we can move on and practice the thin ones. Pay attention here: if you were tracing the thick ones from top to bottom, then the thin ones should be from bottom to top. We saw this rule when we were talking about Noordzij's theories – now we will be putting this into practice. Write a kind of chain, alternating between thick and thin strokes (see below). The thick ones will be the same, as in the previous exercise, straight from top to bottom, but this time each thick stroke will be linked to another with a thin one, which will go up from the baseline to the x-height. The direction will be diagonal and slightly curved, resembling an Italic *n*. It is essential to maintain an angular rhythm, and ensure the shapes are not rounded. The width of each of these modules should be around 10 mm.

▲ When making the first lines, ensure that they are consistent. Keep the thickness, the inclination and the separation between them constant, using the sample above as a model. Notice also the slightly oblique terminals. This means that the brush is being held correctly.

When incorporating the thin lines, keep the thick ones straight, as in the first exercise; drawing a saw-tooth-shaped structure (on the right).

For these strokes, you must write with the tip of the brush, using hardly any pressure. You should get a thickness of 1 mm at most, but do not fret too much over this: for the time being, concentrate on maintaining a certain contrast between thick and thin. Be patient, and practice until you get a feel for controlling the brush (which, I warn you, might not initially be easy).

Now it is time to start writing. In the example on the opposite page, you can see letters organised into groups. We will start with the family of the letter *n*, which shares shapes with other letters, such as *m* or *u*. When we have assimilated these shapes, we will move on to the next family, which is the one that features the shape of an *a*. We will then go on to visit each group of letters until we have covered them all.

BRUSH WRITTEN CURSIVE

il *nmhr*
basic strokes: i l n family: n m h r u y j t

uyjt *adq*
a family: a d q g p b

gpb *oec*
rounded: o e c

vwxyzk
diagonals: v w x y z k

fs *ssrfg*
uncategorizable letters: f s variations of certain letters

- Always be aware of maintaining a sense of rhythm, especially when it comes to the thickness of lines and angular shapes.

- Move forward with the groups progressively: start with the basic strokes, follow with the *n* family, then the *a* family and so on, until you complete the alphabet.

- Do not write letters individually, but try to add to your repertoire little by little while continuing to practice the previous ones.

- Remember to keep the logic of thick-down and thin-up. This also applies to descenders such as the tails of the letters *y*, *j* or *g*: when going up, loosen the pressure to achieve a thin line.

- Round letters are written with a single stroke, and to the *c* we add a small serif at the end of its top terminal.

- We have already seen how the position of the brush is perpendicular to the direction of the stroke. Therefore, when making horizontal strokes like the *t*, *f* or *z* bars, you must change the angle, in the same way we do when making pronounced diagonals like *x*, *y*, *z* or *k*.

I will give you some advice for practising correctly, because if you have not done calligraphy before, it is easy to fall into a series of common mistakes that are more counterproductive than helpful.

Move forward little by little. I understand that you might be eager to write your pet's name, but you will have to wait until you have assimilated the forms of all the letters to write it well. As you can see on the previous page, I have not organized the example alphabetically, but in the order in which you should practice it. As I explained before, start with the basic stroke and go through the families of letters. We do this because, on the one hand, some forms are more difficult to execute than others and it makes sense to advance in order of difficulty. On the other hand, as you know, some letters are derived from others, so in order to write, say, an *a*, it is important to have assimilated the form of the *u* beforehand. The letters may be similar in shape, but the latter is easier to write. In short, I have organized the letters according to the progressive order of difficulty.

★ At the risk of making an unpopular statement, I will say this openly: drawing individual letters is useless. Well, at least it is if what we are after is lettering. Drawing a single letter can be interesting in principle, but from my point of view, it would be closer to an illustration exercise than to a lettering one, since we will not have a set of letters with which we can define a rhythm. And rhythm, as we have seen, is what we are really after in this discipline. Still, individual letters can have certain uses, such as making a collection of capitals, although these are normally very specific cases.

Write text, not individual letters. We will start with the family of *n*, but this does not mean that you have to write one line of *n*, one line of *m*, one line of *u* and so on. Ideally, you will practice all of the letters at the same time, and a great way to do this is to write snippets of text.

While it is true that writing words using the letters exclusively from the first letter family is next to impossible, the idea here is to write groups of letters that look like words. Try writing groups of letters that form fictional words, such as *nimhu* or *jinhu minimum*. In this way, we will not only be practising the forms of the letters, but also the rhythm, the spacing and the relationships between them. On the other hand, if we were to write letter by letter, we would probably have forgotten how to write an *n* by the time we reached the last letter. As we go along, we should focus on incorporating new letters into our repertoire.

Keep up the rhythm. Allow me again to stress that the most important thing in calligraphy is to maintain a consistent rhythm. When using the brush technique, we have to be sure that the thickness of the strokes (both thick and thin) is uniform, to maintain the contrast, and to pay attention to spacing, inclination and the shape of the lettering. We will have to be aware of all of these factors simultaneously when doing calligraphy, and we will have to do so using a technique that is not easy to master. So, once again, be patient. It can take years to really get the hang of a brush, so don't worry if you don't get it right the first time.

BRUSH CALLIGRAPHY

You will notice that I have not included an example using capitals. Do not worry. Simply start from the schematic capital model on page 31 and write it using a brush: you will see how, as you practice and populate it with the minuscule, the capitals will take on dynamic features similar to the minuscule ones.

Once you have internalized the basic shapes of the alphabet, start to work with linked letters, i.e. with a continuous structure and without lifting the brush from the paper (there might be some letters, like *t* or *x*, that due to their structure will require you to lift the brush momentarily, but these will be specific cases). In this way, your writing rhythm will be much more fluid and dynamic, as well as helping you to better assimilate the structure of the scripts when faced with a lettering project.

When working with linked letters, some connections are a little more complex than others. For example, linking the letters *nu* is easy: when you leave a letter, raise the brush until you reach the beginning of the next letter. But there are times when you will have to find more complex ways of solving the ligature without losing fluidity in the line. One way around this is to use loops in our letters that allow us to get from one point to another without lifting the brush from the paper. Although so far the forms we have used come from Italics, loops are more typical of English cursive or *copperplate*. Look at the figure below, where I have written some words using more complex alternative shapes. You must understand that these loops do not merely serve a decorative function, but are necessary to fluidly link the letter.

◀ When we write with linked letters, we can use more complex forms, which in addition to giving a more decorative and complex appearance, endows our writing with a greater dynamism.

★ Notice that when I talk about calligraphy with a brush, I am not using the term drawing, but writing. It is vitally important that we understand the differences this implies. Always keep in mind the differences we have discussed between calligraphy and lettering.

One of the characteristics of brush calligraphy, and the main reason for its popularity, is its versatility. We have seen how by simply starting from a basic model and by being familiar with our drawing tools, we can make a multitude of variations by manipulating the factors with which we are already familiar: weight, shape, proportion, spacing, etc. The difference is that, instead of drawing the outline of the letter with a pencil (as you have done previously), you will have to write it "from the inside" using a brush. Your letters will then be affected not only by the structure, but also by the pressure you apply to the brush, the speed of the stroke, the amount of ink or even the type of paper you use. You will see that as you gain confidence with the tool, your results will become more personal and expressive. At some point you might even want to try working without the help of a grid, which will in turn make your hand gain more confidence. While guidelines are helpful in controlling the height of letters, they might also prevent you from creating more expressive work.

Expressiveness should not only be explored on a purely visual level but also on a communicational one. By this I mean that you should learn how to take advantage of the visual qualities of letterforms to reinforce the concepts you want to communicate. To give an obvious example, you would not use the same letter style to write *What do clouds smell like?* as you would for *Let's sacrifice a goat!* Since the meaning and implications of the two phrases are very different, the visual styles in which they are represented should be a reflection of this.

It is precisely because of this flexibility that whenever an order comes in for "a calligraphic logo", what the client usually has in mind is his or her brand name rendered in some type of brush calligraphy, or at least in letterforms that evoke the thick and thin dynamic derived from calligraphy. That is the reason why I wanted to put an emphasis on calligraphic brush technique in this book, as understanding these shapes will be a vital tool when it comes to drawing scripts.

Well, now that you have discovered how to carry out calligraphy with a brush, I encourage you to continue practising in your own time, and to also try other tools such as the flat pen, the expansion pen, or the flat brush. Calligraphy is a wide-ranging field which is complementary to the lettering techniques with which we are working.

▶ **EXERCISE**

Brush calligraphy can go far beyond the formal restrictions of the example models we have seen, and by making variations on it, we can express different concepts.

So, I invite you once again to create alternative solutions of the models by changing all the variables that you consider appropriate, and to look for typographic styles that are in line with the concepts you are working with.

On this page, I have made examples using the same tool (Pentel® Pocket Brush), which shows the versatility that even just one tool can offer. As you can see, I have looked for a rhythm and a general aspect that reinforces the meaning of each word.

LET'S GET to work!

While it is true that the lettering exercises you have done so far can be classified as mini projects, their purpose largely served to help you put principles, writing styles and specific techniques into practice. A lettering project that stays locked in a drawer and never sees the light of day is simply an exercise in learning. And perhaps, sometimes, one in self-complacency.

In this final stretch, you are going to see ways to take your compositions further, by applying what you have learned to different types of real work: from professional commissions to clothing customization and traditional signage.

Apart from exercising your sense of letter composition and form, you will be tackling some new projects by taking a closer look at new techniques and processes in a step-by-step manner. I will give in-depth explanations of how to approach a job depending on its type, materials and finishes. The aim here is not to provide you with ready-made formulas, but to give you an example of how one can go about solving specific projects, so that you can slowly start incorporating these practices into your work.

PROJECT PHASES

To be honest, I cannot say I have much of a work process myself – I do not think in that way. Each project is different from the rest, and therefore, each of our jobs will have a unique process. At best, we can divide our projects into categories. They will all have some common ground between them, though some will lean towards calligraphy, others might be more typographic, and some will be more concerned with composition or decoration. In a field in which the possibilities are as wide-ranging as any, it might not make much sense for us to talk about a standard work process that will always work, since for each type of project the strategy will be different.

However, we can more or less identify a few phases that are common to all kinds of work. It is essential that we understand and respect each of these steps in order to always have our project under control. As you will see, it is a fairly logical process.

Research. Before we start a project, we must collect information about it. It might be that we receive an assignment that is related to a subject that is familiar to us, or with a particular aesthetic that we happen to like. But this is rarely the case in the professional world, as clients are a varied bunch. Investigating the subject of a commission thoroughly is a tried and tested way of starting on the right trajectory.

Let's take an example: you have been asked to draw a logo for the cover of a Norwegian Satanist black metal album. You are more of a classical jazz type who has never heard of the band "Mayhem" and has absolutely no clue what the "Inner Circle" is. The aesthetic you are dealing with here is very specific, and it stands to reason that you cannot carry out this project successfully if you do not first look for references.

So, for starters, you should take a look at information about the band you will be working with. You might want to start by listening to their complete discography (good luck!) and analyse their album artwork and concert posters. Of course, you should not just stop at this band, but explore other similar bands from the same period and from all over Scandinavia. The idea is to slowly familiarise yourself – especially from a typographic perspective – with the aesthetic universe in which you will now be operating. You should not only collect examples but also analyse them and understand why certain letter shapes and styles are capable of transmitting a particular concept or emotion.

> ★ It is important to always carry out in-depth research, especially when dealing with subject matters which are unfamiliar to us. That said, you should also be very careful with subjects that you are familiar with, as it is easy to fall into clichés. To give an example, when thinking about the graphics of the '50s, a series of ideas related to typography, image and colour come to mind, yet all of them are derived more from a romantic or revivalist image of this decade than anything else. In reality, a quick look at actual graphics from the '50s will reveal that it was all quite sober. To obtain the best result, always use the best research sources.

PROJECT PHASES

Proposals. Once you have understood the aesthetical rules that your project should follow, it is time to start generating proposals. At this stage, quantity should be more important than quality as the most interesting thing now is to see how many proposals you can generate – to have more variety, and to be able to choose the most suitable one.

Remember to make quick and small sketches. Think of the advice I gave you on page 41: start small and end big. Depending on the approach you are taking, your first drawings might focus more on letter styles, structure or composition. Whatever the case, do not waste too much time on details.

Once you have several options to choose from, you will have to start making decisions: one of them will eventually go on to be the winner. In the first round, it will be important to discard those options that you clearly think will not work. Next, you will have to decide which option will be "the good one", settling on the one that is most in-line with the project's objectives. If the work is a project commissioned by a client, we will usually send them the proposals that we think can work best, and either leave it up to them to choose the final one or come to an agreement together on which the final one should be.

Development. If you recall the AVIONES exercise on pages 51 and 52, or the composition exercise on pages 68 and 69, you will see that you have already tackled developing a project from scratch. For this next phase of the process, this is the direction in which you should continue working. Use your growing knowledge of letter styles and composition to further evolve the chosen sketches by concentrating on refining the composition, rhythm and details. But remember, all this will not be of much use if the first idea does not have a clear orientation at a visual and conceptual level.

During this phase, it will be vital to keep a critical eye on your progress. It is easy to fall into the trap of moving forward with a sketch that is acceptable, yet which could be improved. An objective stance will ensure that you can keep questioning and testing the quality of the work you are producing, as there will always be something to improve. Check the rhythm of the letters, the spacing, composition, the decorative details; in short, be on the lookout for any possible problems you may have before moving on to the final phase of the work.

> ★ It is important to understand that the direction that a project takes from this point on will be determined by the needs of the project, and not by personal taste or style, especially when working professionally. It might seem obvious, but this is something that is not always taken into account.

Final artworking. This will depend largely on the type of project you are working on, which we will discuss in a moment. Ultimately, it is about producing your final piece, whether that is a digital version which will be reproduced, a painted sign or an artwork on paper.

Whichever the case, we must ensure that we have technical control over the medium in which we will be working. Finishes are as important as all the previous processes we have gone through, since a poorly finished project will spoil all the hard work done so far.

This does not mean that we should be masters in all types of techniques, but rather we should know them so that we can understand which one will be most suitable for our work. For example, if we are going to be working digitally, should we do it in vector or raster? For painting a sign on a window, should we go for water-based acrylics or enamel paint? This book does not have enough space to go into all the possible techniques, but I will be covering the most common ones.

> ★ A good finish does not necessarily mean that everything has to be flawless. Sometimes a technically incorrect finish can end up adding character to our work. See the lettering on page 59: ss far as finishes are concerned, it is a fiasco, but at the same time we gain a certain expressiveness. In this case, the imperfections work in our favour.

UNIQUE ARTWORKS VS REPRODUCTIONS

The way we approach the creation of the final artwork for our projects will be determined to a large extent by one major factor: whether we are creating something which will be reproduced or, on the contrary, creating a single, one-off piece. Typically, this will be directly related to whether the commission is of a professional or a personal nature. On a professional level, a lettering artist largely creates pieces that will be reproduced. For example, if I am commissioned to create a calligraphic logo, I will have to deliver a digital file which will later be applied to multiple formats. If the job requires painting a decorative sign for personal leisure purposes, I will paint it directly on any format I like as a one-off piece.

Still, this is not always the case. If a professional assignment requires painting a shop sign, it will also be a unique piece. On the other hand, if I am creating a series of prints for personal purposes, the work will be reproduced. The important thing here is to have a clear idea of how each case can be technically solved.

A MATTER OF STYLE

Since we are talking about how to approach a project, I would like to give you some thoughts on style. I imagine that it is inevitable that each one of us has a way of doing things, and naturally, as letter writers we end up with a common theme running through our portfolios.

Sometimes I see work done by calligraphy and lettering professionals which offers very little variety in the way of solutions, and this leads to results that look incredibly similar, at least on a visual level. This leaves me with a slightly strange feeling since it gives me the impression that in this case, the focus is not on the project but on the style of the author.

In my case, when it comes to a lettering assignment, the first thing I consider is what that project needs. Regardless of my style, my way of working or my tastes, I start by carrying out some research to establish what the work should look like. The project will probably still end up looking like something I would do, since working manually leaves an inevitable personal watermark on the work.

Still, I always try to keep the focus on finding the best solution for the project. When I see that the style does not suit me – because it is far removed from my way of working, say, or is technically beyond my means – I usually reject the project. I do so because there might be someone else who will do it better. And that is okay. I am not suggesting that this is the only, right attitude, only that this is how I operate. Being someone who adjusts to a project, rather than forcing clients to bend to "my style", allows me to work on a larger variety of projects.

When starting out as a lettering artist, it is essential that you keep the following in mind: do not look for a style or copy one. It is normal to have idols that you want to imitate, and in general, copying is fine, as long as you do it as an exercise and to understand the way a particular person works. But do not take that as your style, because besides being unethical and uncreative, it is also very boring. I also believe that you should not be obsessed with finding your own style, as that leaves you operating on a very superficial level. Style does not arise from using a series of visual solutions, but from employing your own personal way of working and understanding letterforms. And that is something that can only be developed over time, not copied.

▶ **PROJECT**

▶ **Objectives**

- Understanding the concept of reproduction in a lettering project
- Seeing the different ways in which a project can be processed digitally
- Appreciating the decisions that need to be taken when designing a logotype
- Observing how a logotype can be applied to different media

▶ **Materials**

- 2H pencil
- Brushes
- Markers
- A photo editing program such as Adobe® Photoshop
- Scanner

LET'S GET TO WORK!

LOGOTYPE FOR A BAND

The rhythm'n'blues and soul band The Excitements commissioned me to design a logo to be used specifically on merchandising they would sell during their tour.

The type of music that this group plays is clearly influenced by black music from the '60s, so the graphic solution had to have a retro look. Still, the band did not want a graphic that was too '60s, and if it was to take some inspiration from that decade, then it also had to look somewhat contemporary. Yup, briefs have a habit of being ambiguous: the "classic but modern" request is one that often comes up when receiving a commission.

After an exchange of references and images with the client, we decided that the logo should have a script style with an inclined composition. The idea was to write the logo of the band plus a tagline beneath it, which would be placed under the name on the right. A *tagline* is similar to a slogan or catchphrase, and it is used in marketing to refer to a phrase that accompanies a logo.

With this as a starting point, I made several tests, of which you can see a selection on the opposite page. You might notice that all the options have elements in common, such as the use of script-style letters and a similar composition. These were things that were determined previously during conversations with the client. Even so, there are noticeable differences in the letter styles, especially in the band name. The first one is drawn starting with its outline, while the last two are written with two different brushes. If you are familiar with the history of 20th-century graphic design, you might notice that the first two options have a more "1940s" look, and they might bring to mind, say, the credits from a golden-age Hollywood movie. Conversely, the last option balances a retro look with a style that feels much more contemporary.

Apart from the band name, there are other elements that make up the logotype, namely, the tagline and, in the first option, the stars, which fulfil a decorative function and also help to round off the composition, similar to the line that underscores the band name in the first two proposals.

LOGOTYPE FOR A BAND

Option 1

Option 2

Option 3

◀ As you can see, I have used the same compositional structure for testing out different styles of letters, both for the name of the band and for the tagline or the decorative elements.

In fact, the letter combinations are interchangeable, which is something that I had told the client when sending the proposals. Be careful when making these kinds of claims. In this case, the structure and similar letter styles allow this to happen, but on other occasions the styles may not be so interchangeable.

In all the cases, *Hot, Hot, Hot Rhythm 'n' Soul* is actually a typeface that I have inserted digitally. I have used a style without serif or contrast and entirely written in capital letters, as I was looking to achieve maximum contrast with the main script.

The Excitements
HOT, HOT, HOT, RHYTHM 'N' SOUL

▲ Little by little, changes are applied to our proposals. As you can see, the tests on the previous page were done very quickly and without paying too much attention to detail. Here you will notice that I have applied some more energy, having drawn the letters instead of writing them with a brush, although in any case it is still considered a sketch. Nevertheless, it is developed enough to show any changes in form.

After going over the first batch of proposals, we agreed on two things. Firstly, that the option that worked best for us was definitely number 3, but using the tagline from number 1 – the reason being that by having a wider proportion and a lower height, it has a lower profile compared to the original tagline used in option 3. Secondly, we wanted to revise the outline of the letters and remove certain calligraphic references. For this reason, I reinterpreted and cleaned up the forms of the letters, as you can see in the sketch above.

The composition has a diagonal main axis which is not too accentuated, since the overall form has a clear horizontal orientation. The overall composition is balanced by the *The* and the tagline, which are placed in the corners, leaving an ample diagonal channel for use by the band name. These elements can be used to great effect when it comes to balancing compositions and adding to their tension and complexity.

As far as form is concerned, I maintained the thick weight and moderate contrast of the letters. The letterforms are clearly indebted to those of a brushstroke, yet the modulations of the line and the shapes of the terminals, in particular, are highly stylized. Some features, such as the swash on the *E*, the crossbars of the *ts* and the twisted terminal of the final *s*, have the thick, rounded curves reminiscent of soul album covers from the late 1960s.

WORKING DIGITALLY

When working on a project which, as in this case, involves reproduction, an original master artwork is required for submission to the printer, screenprinting workshop or whoever will be producing our project. In the days before the democratisation of digital technology, the originals would have needed to be prepared manually. They were true works of art that were done in ink on paper. Nowadays, methods of production require us to work digitally. Sure, nothing stops us from producing it by hand (I still do this on occasion), but working on a computer means that we can retouch, compose, clean up and perfect the artwork in a manner which is fast and precise. Which means that as romantic as working manually might sound, we cannot deny that working digitally has many advantages.

You might notice that I barely touch upon this subject in this book, and this is not because I am against working digitally. On the contrary, it is because I believe that lettering involves learning a lot more before going ahead and vectorising letters in Adobe® Illustrator or Glyphs®. One of the questions I am asked most often during my workshops is: "How do I do this digitally?" Well, there are essentially two ways of working here: in bitmap (raster) or in vector. According to the type of work at hand, it might be better to use one method or the other. In short, the following is how it works:

When working in bitmap, we normally use a photo-editing program such as Adobe® Photoshop. Typically scanned into the program, your artwork is treated as an image, which allows you to keep its more organic aspects, such as textures and irregular hand-drawn outlines, or even shades of grey or colour, if applicable. We use this technique when we are after a finish which is warm, organic and handmade.

However, if we are looking for a perfectly shaped outline, what we need to do is to redraw the shapes and forms of the letters using a vector program such Adobe® Illustrator or even Glyphs®, an application dedicated to type design. When used with sufficient know-how, vector drawing has the advantage of allowing us to have perfect control over the letter forms.

Choosing to work in bitmap over vector or vice-versa is simply a matter of deciding which one of the techniques is more adequate for producing the finish we are after. Our work involves understanding how each technique functions so that we can easily choose between the two for the best and most appropriate way of working.

The Excitements
HOT, HOT, HOT RHYTHM 'N' SOUL

▶ On the opposite page you can see a selection of different media to which the logotype was applied.

1 Patch

2 Turntable mat

3 T-shirt

4 Badge

5 Sticker

6 Tote bag

The final composition corresponds to the sketch on the previous page. I have applied a series of adjustments to the script to achieve a more consistent rhythm, correcting the thicknesses, the shapes and especially the inclination, which is where the previous sketch had some faults. The size of the *The* is larger than in the sketch as it was too small, and the composition of the tagline has been simplified, as in the previous version it had a somewhat chaotic look. To finish it off, we borrowed the stars from one of the first tests, adding a decorative element and further complexity to the composition and providing the logotype with a link to the classic R'n'B concert posters of the 1960s.

When it came to the final applications, we had to think of a range of colours to make the logo work in two situations: one on a dark background and another on a light one. For the dark version, we opted for a black background and a cream-coloured logotype, and a very dark blue complemented by a pale yellow background for the lighter one. On the opposite page, you can see the applications of the logotype on different media using the two colour versions.

▶ PROJECT

▶ Objectives

• Creating a project that uses a spontaneous, calligraphic lettering style

• Using letter styles not as a unique element, but to create a reading system

• Observing the hierarchy of the different elements

▶ Materials

• 2H pencil
• Markers
• Various calligraphy brushes
• Japanese rice paper
• Differently cut paper shapes
• Card and cardboard
• Sticky tape
• Book-binding spirals

LET'S GET TO WORK!

TRAVEL ALBUM

Now we will do a project in which lettering – or in this case, calligraphy – takes a secondary role. The work consists of creating text for a travel album: a book in which we will put not only photos of our holidays, but also those useless little bits of random paper and small objects that we end up keeping because we feel guilty about throwing them away. Not everyone does these things, but if you are into lettering, the chances are that you are that kind of person.

When making our album, we will need bits of text that work on several levels: titles, image captions, a cover title – i.e. different textual elements that will accompany the rest of the pieces. To give some order to these elements, we will have to provide them with a hierarchy, so that it is visually clear which function each one of them has.

Since we probably have a large amount of texts to write, we will need a strategy for this project. For example, in some cases, it may be more convenient to use freehand calligraphic techniques by writing instead of drawing the letters. This will allow us to work in a more agile way, in addition to giving a more personal touch to our album.

We might find that calligraphy is at a disadvantage here, as it has a greater margin of error than lettering. We can easily mess up when working spontaneously, either because we make mistakes in the text or simply because we do not like the way a word has turned out. To avoid spoiling pages we have already prepared or even the cover itself, we will write on separate bits of paper which can later be affixed to the pages. This way, we will integrate them into the collage we will be composing using the rest of the elements.

For this project, I have created some pages with items collected on a trip I made to Japan. I will therefore look for a series of materials, letter styles and other elements that I associate with Japan. After your own trip, try complementing the material you brought home with you with added elements that are somehow related to the destination or the purpose of the trip, for added effect.

TRAVEL ALBUM

In reality, our album will be a reasonably simple affair when it comes to texts. We will need two types of text in the interior pages: one for the titles and another for small captions, which we will add to photos and clippings. When designing the front cover, we can afford to be a bit more complex in terms of composition, resources and letter styles, as long as we stay stylistically coherent.

Since the destination of my trip was Japan, I have chosen to use a fude-style calligraphic brush (similar to those we have already used), since it is a tool that has its origins in Asia. These brushes give us a look that brings to mind Japanese writing. To be specific, I have used a Pentel® Touch – a small brush that allows me to work at small sizes, making it ideal for captions and notes. For the titles, I developed a capitals, sans-serif letter style with a slight contrast that goes well with the hand-written text. I have also varied the proportion and weight of the letters according to the length of the title. This allows us greater flexibility and a wider variety of forms.

I used two types of paper on which to write: a plain, bright red one that reminds me of Japan, and another that is stamped with a traditional Japanese pattern. Alternating between the two types of paper for titles and captions creates a more dynamic and casual rhythm.

▼ Two examples of the small labels I prepared for the full-size album. Notice how the note that is written with the small brush (also in the photo) is halfway between my writing style and the brush Italics shown earlier in this book. This pen naturally produces this kind of finish, which somewhat evokes Japanese writing.

▶ On the opposite page are two double-page spreads from the album's interior. Notice how the letterings are integrated within the composition that is formed by the various elements.

▼ I wrote both the main title and the subtitle several times on different paper, later choosing the best one in each case.

For the front cover, I used a similar strategy. As you can see, there are two small panels, which I made using the same technique you have already seen. For the main element, the title JAPAN, I first practised the word on Japanese rice paper with a Pentel® Color Brush. I chose to write the title in agile capital letters with some Japanese features thrown in, and I later chose the one with the most interesting rhythm. I tore the paper by hand to give it a warmer look and glued it onto a traditional Japanese fabric with which I lined the cover. Notice how the paper's transparency allows a glimpse at the pattern underneath.

Opposite, you can see two double-page spreads from the travel album, each covering a different theme. The various clippings, images and notes must be balanced and integrated into the composition, and I used different types of adhesive tape to pull it all together. Stationery shops typically have a wide range of material for this type of work, which will vary depending on the style of your album.

JARDINES

Los jardines japoneses son de una belleza plástica que no es ni medio normal. En el centro de una megalópolis como Tokyo, el entrar en un jardín tradicional es como un viaje en el tiempo.

El bosque de bambú del monte del Fushimi Inari es ideal para perderse.

Tuvimos la suerte de ir en otoño, cuando los colores de los árboles eran un espectáculo natural. Aquí tienes un par de hojas secas de arce japonés, frescas son rojo brillante.

En muchos sitios puedes estampar un sello. Arriba tienes el sello del parque de Nara, con sus ciervos y todo.

LETTERING

La caligrafía japonesa es, de manera muy obvia, el origen de todas las formas tipográficas, desde las manifestaciones más tradicionales a los usos más contemporáneos. Aquí tenéis una selección del millón de fotos que hice.

En usos que podrían ser tan prosaicos como la señalización de un parque, una intervención en el espacio o incluso la tapa de una alcantarilla, la belleza de los signos y el respeto por las formas es evidente.

▶ PROJECT

▶ Objectives

- Using lettering to customise a personal object of everyday use
- Painting on textiles
- Transferring a design to a surface

▶ Materials

- Denim jacket
- Pencil
- Marker
- Synthetic paintbrushes
- Acrylic paint
- Carbon paper

LET'S GET TO WORK!

PAINTING A DENIM JACKET

If my memory serves me correctly, one of my first "lettering projects" consisted of painting some Gothic letters on a pair of jeans when I was 14. Fortunately, no evidence of this project has survived, but it is safe to assume that it was a disaster. Whatever the result, the idea is still a valid one, so here we will be seeing how to customise the back of a denim jacket.

I intend to fill up the back of the jacket with letters – the bigger, the better. I mean, not to do a tiny intervention but to go all out. I have chosen the phrase *Girls invented Punk Rock not England*, which Kim Gordon of the band Sonic Youth wore on a T-shirt as a way of asserting the role of women in music. The length and content of the phrase allows for a complex composition, a very marked hierarchy, and the possibility of interesting letter style combinations.

The first step is to prepare a sketch with the measurements of the back of the jacket we will be painting and to start testing different compositions on this template. On the opposite page, you can see the final sketch (with the size template in the background), which was chosen from a series of sketches that were progressively adjusted so they fitted the back of the jacket well.

As the sentence is relatively complex, I had to set up a hierarchy at several levels. The main element here is *Punk Rock*: two relatively short words that are also in the middle of the sentence and which therefore can form a compact focal point in the centre of the composition. On a second level, we find *Girls Invented* and *not*, with *England* on the third level, concluding the sentence.

I have chosen to use two very different styles of writing for this phrase. *Punk Rock* uses a very distinctive cursive style, which is quite condensed and is very bottom-heavy in its weight distribution. This style was very popular at the turn of the 20th century, although in this case, I have given it a modern touch by making the forms a bit simpler. This same style is used for *England*. I think it is fun to juxtapose a sophisticated style with a phrase about punk rock. Conversely, for the rest of the text I have used a sans-serif style that lacks contrast, and is designed to be painted directly with a brush, without having to paint its outline first. This simple style contrasts dramatically with the complex nature of the cursive, producing a very interesting combination.

PAINTING A DENIM JACKET

105

◀ The sketch drawn onto a template of the back of the jacket, with the location of the textile seams marked out.

▲ It is important to fix the sketch onto the textile well, so that it does not move while we are transferring the design.

Next, I printed the full-size sketch. As it was larger than an A4 sheet, I printed it in parts on four sheets, glueing them together to create a full-size template (you can also do this by photocopying). I then mounted it onto the jacket, carefully placing it in the same space I plan to paint. We are now ready to go on and transfer the lettering onto the denim fabric of the jacket.

To do so, I used carbon paper. There are many colours, and in this case, I needed a bright tone to contrast and be visible over the dark blue of the denim. The carbon paper is placed between the template and the jacket, and when we retrace the lettering with a pen, the design is transferred onto the fabric. At this point, the pattern must be very well fixed to the jacket, because if it moves in the middle of the process, we will have a problem.

Once we have transferred the design onto the fabric, it is time to start painting. At this stage we will need to have some confidence in what we are doing, since we do not want to ruin the piece (throwing it away and buying a new one is probably not an option). So, before getting anywhere near the jacket with a brush, I carried out some tests on a piece of similar fabric with various paints and brushes to see how they behaved and how they might act in the final piece.

It might seem that the most logical thing to do when painting on denim is to use textile paint. To be honest, I have done tests both with textile paint by various brands and with acrylic paint, and I did not notice any difference. I would even say that ordinary fine art acrylic paint works even better than textile paint in some aspects. Well, for this job I used Vallejo® Acrylic Studio paint, which is very cheap and easy to find, and works well both when applied and when washed. The paint comes in a very thick and pasty consistency, which could make it very complicated to apply on textile, so diluting it with some drops of water is recommended. Some textile paints require the design to be ironed after it is painted, for increased paint adherence. In addition, pigment manufacturers also recommend washing painted clothes on the washing machine's delicate setting. Frankly (and to make sure that what I am explaining in this book works), I have tested it with the opposite of what is supposed to be technically correct – by using paint that is not made for textiles, diluting it with water (it is said that this is not good for adherence), not ironing it and chucking it into the washing machine for a standard wash – and it came out great. Now that's punk rock!

As for the brushes, we need to keep in mind that painting on this tough surface is complicated. You will get the feeling that the paint is not covering well and that it is hard to spread around, which is absolutely true. So, for this task, you will need hard, synthetic, flat and short-haired brushes, as these characteristics will help you exert more pressure on the paint, allowing it to better penetrate the fabric.

Now that we have the materials clear, let's get right into it. As I said before, dilute the acrylic with a few drops of water before applying it, as it will help it flow better. If you feel that it is still too thick, cautiously add some more water, without making it too thin. If on the other hand, you find that it is too liquid, add more paint.

PAINTING A DENIM JACKET

107

◄ On the opposite page are three photos showing the three layers of paper: the sketch template, the carbon paper (heavily used), and the transferred design.

◄ As you can see in this image, the lines are visible enough to allow you to paint comfortably. Be careful about which carbon paper you choose. If it is too greasy, it can leave a residue. This one from Pelikan® can be removed with an eraser, or with a wash.

▲ Notice the difference between the first layer, which has insufficient opacity, and the second one, where the colours, although not totally opaque, are sufficiently bright.

▶ On the opposite page is a young punk rocker sporting her brand new jacket in London's Soho area.

Since the jacket is relatively dark, I went for a fairly bright colour palette that would contrast well with the background. Even so, I wanted to keep a certain chromatic nuance, so I selected colours that were inspired by the Union Jack, with the blue brightened up a notch to make it stand out from the dark blue of the denim.

When painting, we must apply at least two layers of paint, because as you can see in the images above (left image), just one coat is simply not bold enough. If white paint, which is relatively opaque, is not enough, then one layer of a weaker paint such as blue or red will leave only a slight trace of colour once it dries up.

So, after priming the fabric with the first layer (always white), we must apply a second one, regardless of whether the final colour is white or red or blue. In this way, we will get a good opacity and bright colours. Notice how the colour is also not totally flat but has a translucent feel. Such a finish, I think, fits in perfectly with the punk spirit of the piece. Still, if we want more opacity, then we can always apply one more layer.

There is another technique for painting on denim which consists of cutting out the design on an adhesive paper, creating a sort of stencil which is stuck to the fabric, and then applying paint with a sponge. This way, we will get a cleaner outline and a more opaque finish. But I am sure you will agree that we are nothing like "those kinds of people", and prefer to use more genuine methods.

▶ **PROJECT**

▶ **Objectives**

• Creating a decorative object for your home

• Painting on wood

• Transferring a design to a surface

• Creating letter effects through colour

• Making letters look aged

▶ **Materials**

• Pencils
• Chopping board
• Flat brush
• Acrylic paint
• Sandpaper

LET'S GET TO WORK!

DECORATIVE SIGN

Here we have another project that consists of painting on an object. In some ways, it is similar to the previous one, but we will encounter some other, more technical challenges.

In this case, we will be painting a small decorative wooden sign for a household kitchen. Instead of ordering a custom-cut board, we will be using a chopping board. Seeing as it will be hanging in a kitchen, I thought it would be more than appropriate to use something which, at least, has some culinary value.

The text I have chosen to write is *Hay caldo de gallina*, which in English translates to *We have chicken soup*. It is a phrase that one commonly sees inside age-old mom-and-pop bars in Spain, and therefore has a traditional and rustic ring to it. I think it is fun to take it to another level and to create it as a tribute to these types of establishment.

Within the sentence, the most prominent word is CALDO (SOUP). The rest of the elements will be at a secondary level, almost acting as a frame for the main word. To make CALDO stand out further, I will use a couple of classic tricks from the signwriting trade.

The first step will be to sketch out compositions which are adapted to the dimensions of the surface on which we are going to work. To do so, I made a scaled drawing of the surface, on which I then started to distribute the text. As you can see in the sketches on the next page, the first drawing is done rapidly and without paying too much attention to what the lettering should look like – for now, the only thing I have decided is that CALDO will have a very specific shape. The bottom part of the word is aligned flatly to the baseline, while the top part will cave inwards, with the letters adapting to this shape. Therefore, the first thing we will do is distribute the letters within the width we have available. Once we have planned the space that each letter will take, we will draw them according to the abnormal shape created by the top line. In this case, I have used heavy sans-serif letters with a slight contrast. Since the style is fairly clean, the rest of the text can afford to be more loose and spontaneous and written directly with a brush. But first, we are going to focus on the main word of the composition, for which we will be using more complex techniques.

DECORATIVE SIGN 111

The letters will not be coloured flat but will use an effect known as *convex bevel*. By painting them in several tones of the same colour, I will give the letters the illusion of volume. To define the areas that will be coloured-in differently, I will draw a line running through the centre of the letters' stems, which will connect to the corners of a letter when it approaches a terminal or between the different parts of the letter.

Once the areas are defined, I will assign a colour to each of the areas. In this case, I have used four colours (this technique can also be done with two or three). According to basic art theory and the colours indicated below (see illustration), and if we consider that a source of light is located towards the top left of the word, the upper surfaces will have the colour *1*, the bottom *4*, the left *2* and the right *3*. Easy. A more complex letter will be just as simple; it is all about following the logic determined by the direction of light.

It is essential that the four colours are tones of the same colour, or that they are at the very least related, to obtain a relatively realistic result. In this case, I used a range of turquoises, to contrast with the warm colour of the wood and – frankly — because it is the colour of my kitchen wall.

▲ Two phases of the same sketch. On the left, I have simply distributed the text. Once I have it all arranged, I go on to give the letters shape and weight.

▼ Below you can see a scheme that shows how to apply the different tones to the different surfaces of the letter, based on the location of the source of light.

▲ Fix the sketch onto the wood well before retracing the lines: remember that it should not move.

▼ Using a soft pencil, we can easily create our own DIY carbon paper, and it still works great.

As you can see in the sketch above, I have gone ahead and drawn the areas that will be filled with the different colours, numbering each one. Now, it is merely a matter of painting by numbers. Observe the way the terminals, and especially the joints, between different stems are drawn. When it comes to curves, I have solved the area where two colours meet by using a curved line, although a simple straight cut will also do or, if you are good at painting, a smooth gradient.

Once we have defined the design of the letters, it is time to transfer it to the surface. In this case, we are going to do it in a more rudimentary way than in the previous project, but still as effective. I have printed a version of the sketch which has been enlarged to its final size. Next, I shade in the entire reverse-side of the sketch with a soft graphite pencil, such as a 2B, creating DIY carbon paper.

When I have affixed the sketch in its definitive position onto the surface or the chopping board, I retrace the lines of the sketch lightly to transfer the lines onto the wood. A light touch is key here, as the wood is soft and I do not want to risk making deep marks in it. Once this is done, it is time to start painting.

DECORATIVE SIGN

◄ Each of the faces of the letters is painted in one colour at a time. It is important to let the paint totally dry, especially before switching colours.

As always, we need two things for painting: paint and brushes, and once again, I have chosen acrylic paint. Water-based paint is easy to mix, dilute and clean and is relatively opaque. As for the tools, I am using Mack® 2179 signwriting brushes, made especially for water-based paint. In the next project (in which I paint a shop window), I will be explaining the characteristics of signwriting brushes, but for now, a small, flat, synthetic brush such as a 4 or 6 will be enough.

Prepare the four colours in one go to have them ready. In this case, I prepared colour 2 first and later prepared the rest of the colours by making colour 2 lighter or darker. Any colour can be used as the primary tone, depending on the brightness you want it to have. If you use 4 as the primary colour and the rest are lighter versions of it, the resulting palette should be a luminous one. If, on the other hand, the original is 1 and the rest are darker versions of it, the overall palette will feel denser.

★ Prepare all of the colour tones before starting to paint and do not discard them until you have finished the piece. You might need a bit of each colour for re-touching details at the end of the process.

The colours are painted in, one by one, starting with the brightest and ending with the darkest. Each colour must be allowed to dry thoroughly before painting the next one, to avoid mixing them in areas where they overlap, and also because we do not want to touch the fresh paint with our hands while we are handling the board. It might take until the application of the fourth colour to see the composition come together.

> ★ While sanding, if you see that the wood around the letters is getting smudged, do not panic: it is just freshly sanded paint. You can remove it with an eraser.

The next phase consists of artificially "ageing" the paint to give it an old and worn look. To do this, we will give the surface a gentle scrub with a medium grain sandpaper (I used one of 150). In my case, the board I used was the cheapest I could find at the pound store, so the wood was naturally untreated and unpolished, with very rough and uneven wooden grains on its surface. Therefore, when sanding, the parts that are exposed the most will be the first to disappear, which should result in a reasonably authentic aged look. Do not worry about the thinner layers of paint as they will also be affected, and the end effect should be quite interesting.

▶ Notice how the paint has been scratched according to the wooden vein texture of the board, giving it a natural-looking aged effect. Observe too how the translucent qualities of the white paint allow the pattern of the wood and the turquoise paint to come through.

▶ On the opposite page is the finished piece. As you can see, the overlap of the white letters over the main word results in a more compact and homogenous composition.

In the last step, we will paint the rest of the text. To add some lightness to the composition, I decided to go for a bright white. As I did not want to lose the white's bright intensity, I wrote this text *after* I had treated CALDO with the sandpaper. Since white acrylic paint is not totally opaque, it allows the colour of the wood to come through slightly.

For this text, I used a type of lettering adapted from a traditional signwriting style, which we refer to as "casual". It is painted directly with a flat brush, and for this reason, we might say that it is a calligraphic type of lettering. It is characterized by a fresh and dynamic appearance, which contrasts sharply with the rigid and solid style used for CALDO. In terms of composition, the white text slightly oversteps the main word. This leads to a more compact setup in which all the different elements relate better to each other.

HAY CALDO DE GALLINA

▶ PROJECT

▶ Objectives

• Understanding the concept of traditional sign painting

• Getting to know the tools and materials used in sign painting

• Learning the process of scaling up a sign

• Working on glass and using solvent-based paints

▶ Materials

• Pencils
• Kraft paper
• Sign painting brushes
• Synthetic enamel paint
• Paint solvent
• Paper cups
• Masking tape
• Paper towels
• Body oil

PAINTING A SHOP WINDOW

This last project brings together a series of challenges of a certain technical complexity that give us a glimpse of what traditional sign painting is all about. For this project I will be painting the display window of my go-to barbershop, *Barber Shop de La Vila*.

As part of the traditional crafts revival of recent years (such as the lettering artist's), gentlemen barbershops have become commonplace. Yet, far from trying to reinvent themselves, they generally embrace an aesthetic that matches their traditional ethos. In the case of my barbershop, the decoration of the premises is rich in artefacts, old-time packaging and vintage ads. Therefore, it follows that the sign to be painted on the glass has to fit in with this aesthetic.

The first step was to send the owner of the barbershop some stylistic tests. Before making any sketches with the real text, I made a couple of quick mock-ups, covering the shop window using some similar-looking signs which I had done for other projects, so that together we could get a feel for the direction that the sign should take. Once the style was in place, I then followed the usual process: I first made a small sketch to visualize the idea and the composition, which I then worked up to a larger size to better control the detail.

Even if the style of the sign is inspired by Victorian graphics, I did not want to do something excessively overloaded or pretentious, as it is only meant for a small, local barbershop. The sign uses capital letters for all of its letters. The hierarchy gives priority to *Barber Shop*, to which I have added some small serifs and some decorative motifs in the initials, which are bigger than the rest of the letters. Underscoring the title is *de la Vila,* which is written in simpler capital letters. The main words have a diagonal distribution and are balanced by the placement of the secondary text in the lower right corner. A flourish of decorative motifs fills in any gaps and adds some complexity and depth to the whole composition. As a decorative effect, I have added a solid drop-shadow to the main words, which will impart a three-dimensional effect and make the sign visually "jump out" of the display.

PAINTING A SHOP WINDOW 117

The client liked the composition and the letter style very much, but we found it a bit more difficult to agree on the decoration, i.e. the series of fine floral lines that surround the letters. The first sketch I made was very elaborate, and the second one was perhaps a bit too sober. With the third one I went for the middle ground and we finally had a winner.

◀ A page from my sketchbook that shows the first sketch I did for this job. Despite not being rich in detail, it gives a clear idea of the direction of the piece.

▲ Some quick mock-ups (or photomontages) using a photo of the shop's display window. The texts used are not final since they belong to other projects, but they serve to indicate the desired stylistic direction.

◀ With a more developed sketch in place (which you can see in full on the next page), I did various decoration tests to see which one worked best.

▲ The final sketch, shown here at a slightly smaller size than the original. Do not obsess over perfect finishes as this is just an intermediate step in the whole process. Even so, the sketch will still need to be fairly conclusive with regards to composition and letterforms, as it will condition the outcome of the pattern you will produce based on the sketch.

The image above shows the final sketch that was approved by the client, with the decorations falling somewhere between the two options shown on the previous page. The next step is to prepare a pattern, where the sign is drawn on paper at the actual size. This drawing will serve as a guide when painting the sign on the final surface, and it will need to be prepared differently depending on whether we are going to use it to paint a wall, a panel or glass. In this case, we will simply draw it on a thin paper (I used white Kraft paper) and stick it on the outside of the window. When set against the incoming light, the transparency of the paper will allow us to trace the letters onto the glass from the inside. Remember that letters will look mirrored when viewed from the other side.

Painting from the inside will make the colour look flatter and cleaner from the outside. Plus, our sign will also last longer as the paint will not be exposed to the weather, keeping the sign looking good.

PAINTING A SHOP WINDOW

To draw the template, we will need to blow-up the sketch. We can do this in various ways. Technology allows us to scan it and have it printed on a plotter, or to have the design projected onto paper, where we can retrace it. But why rush when we can do it in a slower, more traditional fashion? What we can do is apply the classic grid method. As you can see in the photo above on the left, I drew a grid on the original sketch with lines every 2 cm. On the larger paper on the right, I have drawn the same grid using 10 cm intervals, using both grids as my guides and references when copying the letters from the smaller sketch onto the larger template. Cheap and easy!

Next, I chose a colour palette. Seen from the outside, the background (i.e. the interior of the shop) will look dark, and therefore the text will have to be painted in bright colours. For this reason I chose a cream-white, which fits in well as it is the same colour as the front and interior of the shop. As secondary colours, I chose a golden enamel for the motifs and two shades of garnet red for the 3D drop-shadow. When we see that the colour of the interior will be dark, using a colour that is not too bright for the shadow means that the letters end up having more prominence and the shadow stays in the background.

◀ The sketch enlarged to the size we will be painting in – five times larger.

▲ When painting on glass from the inside, I mount the template from the outside with masking tape. If the paper is a thin one, the light coming in from outside will illuminate the semi-transparent template, which acts as a guide for tracing the letters from the inside.

TRADITIONAL SIGN PAINTING

At the beginning of the book we talked about the difference between calligraphy and lettering. Signwriting, or sign painting, is sometimes confused with lettering as well. When we talk about sign painting, we are referring to the craft of painting signs the traditional way, meaning brushes, paints and other tools, although if we are being purists, that also means absolutely no computers. It is a craft that employs techniques from disciplines such as calligraphy, lettering, chemistry, transport, carpentry, cleaning and many more.

In recent years, following a long and dark period brought about by the proliferation of digital sign production methods, traditional signwriting has undergone something of a revival. Veteran sign painters are now considered heroes, and the work that some new professionals are producing is truly praiseworthy, especially considering that it is quite a hard and complicated job.

In this chapter we are only taking a brief look at how to carry out a small sign painting job – mastering the processes necessary to achieve a certain solidity at work requires years of practice and experience. The techniques are very varied; the materials are very specific; the paints and solvents are toxic; and the brushes move as if they have a life of their own. In short, it is not an easy task. Still, painting your first sign, as disastrous as it may be, is an incredibly pleasant experience.

Anyway, before you pick up a brush, you must understand that the most important thing when painting a sign is that the composition is well thought out and that the letters make sense. If the design is not well resolved, then an excellent paint finish is of almost no use. So first of all, immerse yourself in this book. After that, move on to learning the specific techniques of signwriting. In the bibliography, you will find some books about the discipline, and the internet is full of videos and tutorials on how to paint signs. But, if you are serious about learning, you should look for a course or workshop with someone who can teach you the basics of traditional sign making. It is now easier than ever to find weekend workshops that will teach you how to hold the brush, thin the paint or prepare a template – things that no video tutorial can ever teach you well.

▲ American sign painter Mike Meyer travels all over the world, giving workshops for those starting out and for advanced sign painting techniques too.

TRADITIONAL SIGN PAINTING

Let's now talk a little about the materials and tools needed for this project, since this is usually the part that raises the most doubts. Once again, the materials for painting signs can change significantly depending on the surface (paper, glass, wall, wood etc.), the location (interior or exterior) or the permanence needed (temporary or permanent). The brushes that we will use to paint on glass will be different from those for walls, just as paint made for wood is not the same as those for paper.

Sign-painting brushes must meet several requirements, such as carrying a large amount of paint that allows us to make long strokes, being very flexible, and being capable of leaving clear marks with the tip of the brush, which can be round or square depending on the type of work at hand. There are many brands of brushes; Mack® is the most internationally recognized and can be purchased from online shops. In the UK, the brushes from Handover are almost a standard. And the Spanish company Escoda® has some specific brushes for sign writing, developed together with the sign painter Adrián Pérez (better known as El Deletrista) – they are the ones I used for this project, and they work wonderfully. You can find them in fine art shops.

When it comes to paint, I have used synthetic enamel, since in our case, the intention is to paint a permanent sign (if it had been a temporary one, I would have used water-based acrylic paint, as it is much easier to remove). The brand that is most associated with signage worldwide is 1-Shot®, developed especially for this purpose. But do not worry too much about the brand of enamel you use – these paints are easy to find at your local paint store, they are very cheap, and their colour range is usually extensive.

Brushes and paint are obviously essential for painting a sign, but during the process I have also used other elements: paper cups for mixing the colours, turpentine or solvent for thinning the paint and cleaning the brushes and kitchen paper towels for drying them, plus body oil for greasing the brushes when they are finished.

▼ A couple of Escoda® brushes. The one with a wooden handle is made from natural squirrel hair, while the one with the black handle is made of "tendo", a synthetic fibre. Brushes need to be taken care of by cleaning them with solvent right after being used, and greasing them with some drops of oil. I use body oil, but there are specific products for this purpose.

▲ The sign, when seen from the inside, matches perfectly well with the decor in the interior.

▶ In this image, you can appreciate the range of colours and the shading detail of the sign.

▶ On the opposite page is the finished sign, as seen from the outside.

★ Here is a little trick: when painting with enamel paint, add a few drops of turpentine or solvent to it. You will see that, far from making it transparent, the paint becomes more elastic and flows better.

When it comes to painting, try working one colour at a time. Since I have superimposed some colours in my sign, the first one to go on the window will be the front-most colour – the cream-white of the letters. Next to go on will be the decorative gold, and finally, the two shades of garnet red. When painting with areas of colour that overlap, it is very important to let the first one dry thoroughly, which means that planning and timing your process is crucial. There are also other things to consider; here, I had to solve the transition between the two shades of garnet. Instead of making a gradual, blended gradient, I painted two lines of the darker colour so there is a slight, graphic transition between light and dark. This is the easiest way to solve this situation.

In the photos above, notice the difference in texture between the colour as seen from the outside and from the inside. From the outside, the paint looks flat and opaque, and the colour looks as it should look. However, seeing it against the light from the inside is a different story, as all the defects, such as brushstrokes, colour overlap and distorted colours, can be seen. Even if, strictly speaking, these are imperfections, they add a certain charm to our letters that is characteristic of handcrafted work. A vinyl sign would have been cut with surgical precision for a clinically clean finish, but these imperfections add a human dimension to our work that cannot be achieved with a plotter.

Barber Shop DE LA VILA

CONCLUSION

As you look back at how far you have come, you can see you have travelled a long way. You began by learning what lettering is and how it differs from calligraphy and typography, and you also saw how it can be applied to real life. After preparing some materials for the exercises, you began to understand what the basic forms of lettering are and how they originated. You then took a close look at a series of rules, which gave you the knowledge to start handling letters with some ease, and allowed you to understand how they work.

After this first fairly theoretical (and necessary) section, we practised with the help of some model alphabets and even did some calligraphy using a brush. The last part of the book gave you the chance to apply all this knowledge to real projects of a certain level, some personal and others of a more commercial nature.

If everything went well, by now you should know a lot about lettering, or at least enough to be able to have a decent conversation about it. Even so, you must understand that these 128 pages are simply an introduction: the beginning of your career as a letterist. There is also the other issue that, no matter how neutral I have tried to be throughout, the information passed on to you has been to some extent filtered by myself, making it just one of many interpretations of "the truth".

So, if you want to keep on progressing, now that you have finished this book, be sure to continue educating yourself: go through the bibliography on the next page, enrol on online courses and attend a workshop from time to time. You will learn a lot from other teachers and will get to know people who are as passionate about letters as you are.

But above all, work. The quickest way to progress is to carry out projects, making sure to accept increasingly varied and complex challenges. Do not settle for a style of letters that "suits" you, but try out different techniques and solutions. Do not forget to maintain an objective point of view as it is the only way of improving your projects.

I hope, however, that by reading this book you have learned and enjoyed yourself a lot, and that you have, above all, understood the essence of lettering: that of achieving good rhythm.

BIBLIOGRAPHY

Barber, Ken. *House Industries Lettering Manual*. New York: Watson-Guptill Publications, 2020

Castro, Ivan. *The ABC of Custom Lettering*. London: Korero Press, 2016.

Catich, Edward M. *The Origin of the Serif*. Davenport, IA: St. Ambrose University, 1991.

Gray, Bill. *Lettering Tips for Artists, Graphic Designers and Calligraphers*. New York, NY: Van Nostrand Reinhold, 1980.

Gregory, Ralph. *Sign Painting Techniques. From Beginner to Professional*. Cincinnati, OH: St Books, 1973.

Harvey, Michael. *Creative Lettering Today*. New York, NY: Lyons & Burford, Publishers, 1996.

Hische, Jessica. *In Progress*. San Francisco: Chronicle Books, 2015.

Hughes, Rian. *Custom Lettering of the 60s and 70s*. London: Carlton Books Ltd, 2014.

Knight, Stan. *Historical Scripts; From Classical Times to the Renaissance*. London: A&C Black. 1984.

Leach, Mortimer. *Lettering for Advertising*. New York, NY: Reinhold Publishing Corporation, 1956.

Levine, Faythe, and Sam Macon. *Sign Painters*. New York, NY: Princeton Architectural Press, 2012.

Matthews, E.C. *Sign Painting Course*. Chicago: Nelson-Hall Co. Publishers, 1958.

Meyer, Mike. *The Better Letters Book of Sign Painting*. London: Laurence King Publishing, 2020.

Middendorp, Jan. *Hand to Type. Scripts, Hand-Lettering and Calligraphy*. Berlin: Die Gestalten Verlag, 2012.

Reaves, Marilyn and Eliza Schulte. *Brush Lettering. An Instructional Manual of Western Brush Lettering*. New York, NY: Lyons & Burford, Publishers, 1993.

Shaw, Paul. *The Eternal Letter; Two Millennia of the Classical Roman Capital*. Cambridge, MA: The MIT Press, 2015.

Shaw, Robert. *Practical Lettering*. New York, NY: Original Artworks Ltd, 1956.

Stevens, Mike. *Mastering Layout; Mike Stevens on the Art of Eye Appeal*. Cincinnati, OH: ST Publications, 1986.

Thompson, Tommy. *The Script Letter; Its Form, Construction and Application*. New York, NY: The Studio Publications Inc., 1939.

ACKNOWLEDGEMENTS

Despite having written, illustrated, photographed and designed this book myself, there are a number of people to whom I am very grateful, as this book would not have been possible without them, or it would have been, at the very least, much harder to put together.

I want to start by thanking the editors of the Spanish edition, Jordi Induráin and Àngels Casanovas, and Yahya El-Droubie at Korero Press for having the confidence to publish the book in English.

Alex Trochut, for writing the Foreword. This is very emotive for me, since we have known each other since we were just Alex and Ivan.

Thanks also to my long-time friends and colleagues Juanjo López and Jordi Embodas, for allowing me to use their fantastic typefaces, in which I have set the text of this book. They work exceptionally well!

My go-to photographer, Luis Castillo, gave me sound technical advice when it came to taking photographs for this book. Thanks again, Luis – I owe you quite a few by now.

I also have to thank my professional colleagues Oriol Miró, Nick Benson, Alex Trochut (again), Jakob Engberg of Copenhagen Signs and Taioba for permitting me to use images of their amazing work in the first chapter. With work like that, any book would look great!

Thanks to Marta for letting me show the work done at Barber Shop de la Vila, which was a blast, and likewise to The Excitements.

Mónica Arévalo, who has also appeared in other books of mine, is the girl seen from the back on page 109, while Lino Rodríguez took the photo. Thanks to both of you lovelies. Miguel Márquez is responsible for the photo on the dust jacket. Thanks, amigo. Thanks also goes out to Sam Roberts and Mike Meyer of Better Letters and to Fabrikat, Zurich for lending me the photo on page 120.

Working on a complicated book such as this in record time can cause symptoms of depression, hysteria and irritability that are hard to bear. Therefore, above all, thanks to my Eva, my life companion, for putting up with me and giving me the energy to get through this project.